IMAGES
of America

S.S. CITY OF MIDLAND 41

Chief Engineer Theron Haas, left, and Captain John Bissell, shown in the summer of 1983, played major roles in the operation of the *City of Midland 41* during the ship's last years of service under the flag of the Michigan-Wisconsin Transportation Company. To these men, along with Captain Ernest Barth, and their crew, this book is respectfully dedicated. (Photo by Douglas S. Goodhue.)

Cover Photo: The *City of Midland 41* enters the channel at Ludington shortly after entering service in spring 1941. (Author's collection.)

IMAGES of America
S.S. CITY OF MIDLAND 41

Art Chavez

To Elly

Best Regards,

Art Chavez

ARCADIA

Copyright © 2004 by Art Chavez.
ISBN 0-7385-3253-3

Published by Arcadia Publishing,
an imprint of Tempus Publishing, Inc.
Charleston SC, Chicago, Portsmouth NH,
San Francisco

Printed in Great Britain.

Library of Congress Catalog Card Number: 2004100867

For all general information contact Arcadia Publishing at:
Telephone 843-853-2070
Fax 843-853-0044
E-Mail sales@arcadiapublishing.com
For customer service and orders:
Toll-Free 1-888-313-2665

Visit us on the internet at http://www.arcadiapublishing.com

In memory of Captain Ernest G. Barth (1925–2002)

Captain "Gus" Barth gives mooring orders from the *Midland*'s port bridgewing at West Michigan Dock & Market Corporation's facility at Muskegon, Michigan in September 1985. The ship visited the port to promote cross-lake car ferry service, and carried 465 passengers on an afternoon shoreline cruise off Muskegon. (Photo by Gregg Andersen.)

Contact the author with comments or to be notified of future car ferry projects at: pmcarferries@earthlink.net

Contents

Foreword		6
Acknowledgments		8
Introduction		9
1.	Design Evolution of the Great Lakes Car Ferries: 1888–1940	11
2.	Construction at Manitowoc Shipbuilding: March–September 1940	19
3.	Launch Day: September 18, 1940	25
4.	Fit-Out: September 1940–March 1941	37
5.	Sea Trials and Maiden Voyage: March 1941	49
6.	Shipboard Views: March 1941	63
7.	The Pere Marquette Era: 1941–1947	75
8.	The Chesapeake & Ohio Era: 1947–1983	81
9.	The Michigan-Wisconsin Transportation Era: 1983–1988, The *Midland*'s Final Years	89
Appendix A: General Specifications		116
Appendix B: Profiles and Deck Plans		118
Appendix C: The Skinner Unaflow Steam Engine		122
Suggested Reading and References		128

Foreword

When I met Art Chavez twenty years ago, I never imagined that I would be writing the foreword to his pictorial history on the *City of Midland 41*. The two of us became part of a group of enthusiasts who shared some rare experiences aboard the last Lake Michigan railroad car ferries in their waning years of service. Most of this time was spent aboard the *41*, as the ship was affectionately known. Although the oldest vessel in the Michigan-Wisconsin Transportation Company (M-WT) fleet, she was considered their premier ship. The *41* was kept in operation during five of M-WT's seven years of existence. Together our group got to know the ship, the crew, and the business of car ferrying extremely well.

My own interest in car ferries began in July of 1973 after prodding my dad for a trip to Milwaukee's lakefront. For me as an 11-year-old, it was a welcome diversion after another hospital visit with my terminally ill mother. Upon reaching the lake, we saw a racing inbound ship, deck lights aglow and fully illuminated by the late setting sun. My dad said the ship was a car ferry and took me to its Jones Island dock where together we watched it unload railroad cars. I had a great love of ships, but knew nothing about this type. I didn't pay attention to its name, but outwardly it was different than the car ferry named *Spartan*, pictured on the brochure in my hand. In 1975 I would step aboard the *City of Midland 41* in Ludington, Michigan, for the first time and recognized it as the same ship my dad and I had watched on that beautiful summer evening two years earlier.

On July 8, 1983, fate brought together our aforementioned group. Art Chavez, Ken Ottmann, his wife Trish and daughter Kristin, Tony Robles, and myself met aboard the *Badger* on her inaugural visit to Milwaukee for the newly established M-WT. Our meeting was arranged by Purser John Petrovich. We are forever grateful to John for that introduction. Our group was later joined by Gregg Andersen, Rick Harrington, Jim Gregorski, and John Hausmann. Gregg, having a goal of becoming a car ferry captain, had just graduated from the Great Lakes Maritime Academy. Jim and John, we learned, had spent the late 1960s and early 1970s documenting on slide film the 13 car ferries then operating. With this association in place we went on to witness, from the inside, the final years of Lake Michigan's railroad car ferries. We gained full, unrestricted shipboard access, and were allowed by the crew to become "one of them" and truly live a child's dream.

The experiences that we had were extraordinary, and certainly without precedent; Captains Ernest Barth and John Bissell allowed us the opportunity to wheel the *41* into and out of the harbors. Gregg Andersen, licensed as a navigation officer but working as purser, had his first opportunity in 1985 to dock a car ferry in Kewaunee aboard the *41* under the guidance of Bissell. (In 1993, Gregg became captain of the *Badger* at age 31, becoming one of the youngest car ferry skippers in history.) For me, Captain Bissell's request that I wheel the *41* into Ludington on his retirement trip was a high honor. Chief Engineer Theron Haas taught Art and I how to run the *41*'s 6,000-horsepower Skinner steam engines, and allowed us to operate them on three occasions while arriving and docking in the harbor. It was amazing to feel the throttles and hear the engines react to the change of speed and direction that we effected upon signal from the pilothouse. One might question the wisdom of these men, as the ship and their licenses were literally in our hands. But the mutual bond of trust and respect was just that strong. We believed in them, and they in us. They allowed our dreams to come true, and perhaps through us relived their own dreams.

Never having a twin, the *41* was one of a kind; a "missing link" between the twins *Badger* and *Spartan* of today and the pioneer car ferry *Pere Marquette* of 1897. Built by Manitowoc Shipbuilding Company, the evolution of the car ferries was visible in the *41*'s lines; she was the culmination of decades of refinement. She featured a covered promenade, a fine dining facility, forward and aft lounges, staterooms on two decks, and a staircase in the main lounge forward. Most significantly, she was of the Art Moderne styling, as is the famed *Milwaukee Clipper*, rebuilt at the Manitowoc yard at about the same time. Virtually unchanged from 1941, one could almost hear the big band sounds of the 1940s when stepping aboard, or perhaps the voice of President Franklin D. Roosevelt on her forward lounge radio addressing Congress after December 7, 1941. Those broadcasts were quite likely heard aboard the ship, as she was running at the time.

Today the *41* is a barge, renamed *Pere Marquette 41*, and is pushed by a tug and relegated to carrying bulk cargo. When she was towed away in 1997, many people wept as they saw her off, catching one last

glimpse of her as a whole ship. Now her many parts have been cut away and scattered for eternity. Some reside in museums and private collections, but most went to the steel mills, including her giant Skinner steam engines that we had the great privilege to handle. Art Chavez purchased what remained of the brass letters of her name from the bow, and on March 14, 2003, 62 years and two days after her maiden voyage, we placed them in the model/car ferry gallery in the Wisconsin Maritime Museum at Manitowoc, Wisconsin. Today the 21-foot length of her name, *City of Midland 41*, is mounted high and prominent in the city of her birth.

It is unfortunate that many will never fully know the *41*, particularly the youth of today and tomorrow—the youth we once were. I only wish that the ship's sights, sounds, and smells could be conveyed within this book. The early morning scents from the galley wafting topside as breakfast was prepared—bacon, eggs, pancakes, and coffee—accented occasionally by a wisp of coal smoke. The roar of her bow wave, heard during a solitary stroll forward on a moonless, warm summer morning at 3:00 a.m. Seeing the brightest stars reflected on a mirror-like surface of Lake Michigan, with a glance overboard revealing a perfect, fully lit reflection of the ship cutting through the water. The ringing of her engine room telegraphs during docking, accompanied by the shudder of her engines and churn of the water. And her "voice"—the huge steam whistle on her smokestack, which could be heard ten miles inland on a cold sub-zero night.

I believe that these last special crewmembers of the railroad car ferry era saw the end coming and took us in. They allowed us to live, feel, and record this historic period as it unfolded before us. Unknowingly, we became intimate witnesses and custodians of the details in this closing chapter in Great Lakes maritime history. We were privileged to know the *City of Midland 41* and her crew during her final days. Our mission now is to tell her story, making certain that those who built and sailed her will never be forgotten.

Douglas S. Goodhue
Milwaukee, Wisconsin
July 8, 2003

Car ferry photographer and maritime artist Doug Goodhue kneels beside the *Midland*'s lifeboat No. 2 on June 11, 1976, at the age of 14. The ship is tied up in the Jones Island slip at Milwaukee. (Photo by Dave Hawley.)

Acknowledgments

My sincerest appreciation goes to all of the officers and crew that I was personally acquainted with during my adventures aboard the *City of Midland 41*. They are: Capt. Gregg Andersen, Chief Lloyd Anderson, Bill Bacon, Wayne Bailey, John Baron, Capt. Ernest Barth, Stu Bell, Glen Bentz, Capt. John Bissell, Duane Bogus, John Bogus, Glen Bowden, Mike Braybrook, Nico Brouwer, Jim Cassan, Bill Clark, Dale Clark, Elsie Conway, Jerry Couturier, Frank DiPiazza, Capt. Howard Dobbins, Jim Doner, William Durand, Everett Dust, Phil Eckley, Bruce Eddy, Darrell Engler, Francis Finn, Robert Fox, Leo Garland, Max Garno, Tom Gilland, Joe Gorzynski, Ron Graczyk, Ron Greiger, Marilyn Greiner, Richard Gulleff, Chief Theron Haas, Lyle Hanley, Rick Harrington, Leo Hesting, Earl Hilden, Capt. Jim Hinds, Jake Huggard, Curt Hunter, Harold Hurlburt, Jerry Hutchinson, Roger Johnson, Keith Kalisch, George Karl, Walter Knowles, Gary Larsen, Dennis Laskey, Bill Lemire, Dave Lilleberg, Chief Jim Luke, Bart Mallion, Capt. Bruce Masse, Bob May, Bob McCann, Colleen McCauley, Jean McCumber, Richard McLain, Bob McWilliams, Don Miller, Tom Monaghan, Chief Steve Morong, Jim Mrozik, Don Nanke, Wallace O'Reske, Bob Palmer, Clarence Peterson, John Petrovich, Ron Plowe, Betty Powers, Glen Powers, A.K. Pryor Sr., A.K. Pryor Jr., John Praedel, Dan Ramsey, Ed Regan, Paul Rennie, Gary Reynolds, Capt. Larry Riker, Chief Bob Roach, Andy Rose, Corwin Rotta, Randy Rozell, George Sarres, Floyd Schondelmayer, Ted Schultz, Norval Sharkey, John Shiner, Don Short, Ray Short, Capt. Walter Skibin, Dick Soli, Bill St. Louis, Ron Stark, Bob Steinberg, Ed Stepan, Jim Stever, Capt. Warren Stowe, Max Sutter, Rich Swagel, Richard Sweiger, Vern Swetlick, Bob Tetzlaff, Linus Thalman, George Towns, Don Van Brocklin, Mike Van Haitsma, John Vest Sr., John Vest Jr., Roger Vitucki, Ralph Wiegand, Bob Weinert, Del and Tina Whitmire, Ed Wiable, Kevin Yocky, and George Zwinger. Through calm seas, gale force winds, fog and sub-zero temperatures, they brought us home safely every time.

The following helped me greatly during the course of my research: Molly Biddle, Mary Blahnik, Joan Kloster, Jay Martin, Bob O'Donnell, Veronica Franz, Sarah Spude, Bill Thiesen, and Isacco Valli at the Wisconsin Maritime Museum at Manitowoc; Liz Bender, Suzette Lopez, and Virginia Schwartz at the Milwaukee Public Library; Ron Wood at the Mason County Historical Society; June A. Larson at the Door County Maritime Museum; and Tom Schuler of the Kewaunee County Historical Society. Thanks also to Jim Anderson and Chief Engineer Charles Cart of Lake Michigan Carferry Service; Steve Begnoche, managing editor, *Ludington Daily News*; Marge Miley, retired editor of the (Manitowoc) *Herald Times Reporter*; Nicholas Blenkey, editor of *Marine/Log*; Peter Bregman, Director of Archives, Fox Movietone News, Inc.; Jeff Covert, president, Morton Manufacturing Company; and Sam Steiner, engineering manager of the Skinner Engine Company. All enthusiastically granted me permission to use images from their collections or publications.

I also wish to thank my editor at Arcadia, Maura Brown, for all of her hard work, and to the "dream team" of knowledgeable car ferry enthusiasts for their years of friendship, assistance, and encouragement: Arthur Ackerman, Donald Ackerman, Carl and Mary Blahnik, Audrey Boals, Glen Bowden, Terry Bruce, Andy and Beth Buelow, Jim Cabot, Charles and Elsie Conrad, Tom Cubberly, Steve and Carole Elve, Roger Genson, Doug Goodhue, Jim Gregorski, Erik Jonasson, Max and JoLynn Hanley, Bill Hansen, Heidi Hansen, John W. and Carole Hausmann, Frank Heine, Andrew LaBorde, Harold LaFleur, Michael Leon, Art MacLaren, Art Million, Marv Modderman, Mary Modderman, Mike Modderman, Ken, Trish, and Kristin Ottmann, Bob and Grace Peppard, John P. Praedel, Tom and Melissa Read, Tony and Shelley Robles, Jeff Rogers, Floyd and Karin Schmidt, Fred Schmitt, Jill Skiera, Bob Strauss, John Teichmoeller, Bob and Barbara Vande Vusse, Jean Wienand, Roxy Wienand, Wendell and Joyce Wilke, and Tom and Sue Younk. Special assistance was rendered by Gregg Andersen, Doug Goodhue, John Hausmann, Max Hanley, Ken Ottmann, Trish Ottmann, and Bob Vande Vusse.

Technical assistance was performed by my good friends Dan Brown of D & D Photo, Dick Gifford of Advanced Photo, Chris Winters of The Winter Studio, and certified flight instructor Len Jablon, of Len Jablon Helicopters of Northbrook, Illinois. My love and gratitude are in order to my parents and siblings, who endured years of car ferry talk from the eldest of six children. Now my wife Faith and new daughter Lydia must bear this burden.

INTRODUCTION

Few Great Lakes ships have ever caught the public's interest like that of the Pere Marquette Railway Company's railcar, automobile, and passenger ferry *City of Midland 41*. Built in 1940 and 1941 by the celebrated Manitowoc Shipbuilding Company of Manitowoc, Wisconsin, "Hull 311" was easily the most famous and high-profile commercial project ever undertaken by the yard. Commonly known as "the *Midland*," she was more often referred to as "the *41*" by those who knew her well. Aesthetically, she was revolutionary; her outboard profile reflected the "streamlining" trend that had emboldened the artists, architects, and industrial designers during the 1930s. As built, the liberal use of white paint gave the ship an aggressive, yacht-like appearance. The ship's propulsion system, while not revolutionary, was still noteworthy. Her twin Skinner Unaflow reciprocating engines were the largest of their type at that time. The ship and her engines were used to train Navy engineering crews during World War II, crews that were to be assigned to the fleet of *Casablanca* class escort aircraft carriers stationed primarily in the Pacific Theater. These carriers utilized Skinner engines nearly identical to those installed aboard the *Midland*.

During the *Midland*'s construction, there was considerable excitement in the port cities of Manitowoc, Wisconsin, and Ludington, Michigan—her birthplace and homeport, respectively. Local newspapers followed the ship's progress and reported on every detail, from the driving of her first rivet to the appointment of her officers, Captain Charles Robertson and Chief Engineer Richard Langrill. She was an important source of civic pride to the communities' residents during a time of tremendous world upheaval and uncertainty. Judging by the great outpouring of public celebration during the ship's launching at Manitowoc and her maiden voyage arrival at Ludington, the ship represented a welcome diversion. Schools and businesses were closed during the afternoon on both occassions. People were justifiably proud. This latest addition to the Pere Marquette car ferry fleet was well-appointed and modern in every aspect. The Pere Marquette Railway's publicity machine helped to stir up the excitement, as the public and the company's freight shippers eagerly awaited the ship's September 18, 1940 launching. Press releases were distributed to the nation's newspaper, magazine, and newsreel agencies. When sixteen-year-old Helen Dow swung the bottle of champagne across the *City of Midland 41*'s bow, four different camera crews, including representatives from Universal Newsreel and Fox Movietone News, were on hand to record the event. Within weeks of the *Midland*'s grand entry into service on March 12, 1941, her image appeared on the pages of numerous national and international trade, technical, and news publications, including *Popular Mechanics* and *Life* magazines.

The next six years of the ship's service history was spent mostly on Pere Marquette's Ludington to Milwaukee run. As originally intended, the ship was placed on the Manitowoc run during the busy summer tourist seasons. The Ludington to Manitowoc ferry run was an extension of U.S. Highway 10, a major cross-country automobile route. So many passengers rode the ship that crewmembers from other PM car ferries, as well as students working their way through college, requested to be assigned to the *Midland* to work as bellhops and dining room waiters in hopes of earning substantial tips in addition to their standard wages. From 1942 to 1947, the ship served as PM's workhorse, sailing an average of 97,000 miles each year, and averaging 344 calendar days of around-the-clock service. In June 1947, the *Midland*, her fleet mates, and the rest of the Pere Marquette were merged into the Chesapeake & Ohio Railway.

The C&O Railway continued PM's tradition of service excellence, whether it was by maintaining tight sailing schedules, or a cabin maid attending to the needs of a small child in one of the *Midland*'s "deluxe" parlor staterooms. However, such exemplary service was not meant to last. By the mid-1970s, railroad freight, the ferry fleet's prime reason for existence, was being routed more cheaply and efficiently on land *around* the bottom of Lake Michigan, rather than *across* it by boat. By 1983, the *Midland* and her two remaining fleet mates had changed owners once again. The newly formed Michigan-Wisconsin Transportation Company would try to succeed where the C&O claimed it could not.

It was during the *Midland*'s last five years of operational service that I had the once-in-a-lifetime opportunity to know the ship and her master of record, Captain Ernest G. Barth. While I had ridden the ship and knew of Barth during the 1970s, it wasn't until the summer of 1983 that we were formally introduced. He always took the time to visit with me on board the *Midland*, and since his retirement in 1989, extended

an open-door invitation for me to visit him at home on my frequent research visits to Ludington. During the last months of his life in 2002, he still looked forward to talking with me, in spite of his terminal illness. As in years past, we would discuss the history of the car ferries; their triumphs and misfortunes, the people that were involved in their operation, as well as the evolution of their design. I discovered that Barth had high regard for his ship's first skipper, Captain Charles E. Robertson. Like Barth, Robertson had a reputation of being an unrivaled boat handler, both in rough seas or heavy winter ice. Each possessed a gifted ability to "read" the weather. Both men resembled the archetypal seafarer of classic literature, faces weathered by the sun and wind, commanding the confidence and respect of their crew. Both also had a great reverence for the predecessors of their beloved ship. In deference to them, the first chapter of this book will briefly trace the ferries' design evolution, leading up to what is arguably considered the peak of their design, in aesthetics, propulsion, and function—the *City of Midland 41*, Queen of the Great Lakes Car Ferries.

The *Midland* is now a memory, as are Captains Barth and Robertson. Their days of glory have come and gone. May this humble effort pay respect to them, their magnificent ship, and to all of the other men and women who brought her to life.

Arthur P. Chavez
Milwaukee, Wisconsin

Car ferry historian and videographer Ken Ottmann watches the rudder angle indicator as he wheels the *City of Midland 41* on a crossing of Lake Michigan between Ludington and Kewaunee in the summer of 1985. Note the coal smoke pouring from the top of the ship's stack through the window on the right. (Photo by Douglas S. Goodhue.)

One

DESIGN EVOLUTION OF THE GREAT LAKES CAR FERRIES
1888–1940

"Ships have always occupied a special place in the pantheon of human affairs; to those who know them well, ships are alive. They have souls."

—Harvey Ardman, *Normandie: Her Life and Times*

Railroad car ferries (the car in car ferry refers to railroad cars, not automobiles, as in the modern American vernacular) in their simplest form appeared on the Great Lakes river systems in the 1850s. The first river ferries were sidewheel steamers with limited icebreaking ability, and were used to shuttle a relatively small number of loaded railcars across short distances. It was in 1888 that the first railroad ferry was used on a seven-mile run across the Straits of Mackinac. Designed by eminent naval architect Frank E. Kirby, the 215-foot wooden *St. Ignace* was considered a great success with her novel approach at breaking ice: two single propellers, one mounted at the ship's bow, and the other at the stern. By working both screws simultaneously in a steady, deliberate fashion, heavy pack ice was made penetrable. Originally built with an open deck, it was later enclosed in the fashion of Kirby's Ann Arbor ferries in 1892. (Courtesy Robert Strauss Collection.)

In 1892, regional ferry design evolved with the introduction of the *Ann Arbor No. 1* and *Ann Arbor No. 2*. These ships pioneered the development of the large, deepwater railroad car ferry. Like the *St. Ignace*, they were designed by Kirby. His three ferries were lauded internationally as the standard in modern icebreaking. Kirby was consulted and his ships were observed by Russian and British naval and railroad/maritime officials. The front page of the *Kewaunee Enterprise* proclaims the historic nature of *Ann Arbor No. 1*'s maiden trip. (Author's collection.)

As the *Ann Arbor No. 1* was the prototype for the broad-bowed, fully-enclosed long distance train ferry, she was also claimed to be the first triple screw ice breaking steamer in America, if not the world. As simplistic as the design was, the ship was still considered remarkable among the foreign and domestic railroad operators that required spanning large bodies of water, in lieu of cost-prohibitive bridge construction projects. The *No. 1* is shown in windrowed ice off Frankfort, Michigan, c. 1904. (Courtesy Wisconsin Maritime Museum at Manitowoc.)

Frank Kirby's fourth and fifth car ferries were the sister ships *Shenango No. 1* and *Shenango No. 2* (pictured here), designed for service across Lake Erie in 1895. This excellent view shows the ship in Craig Shipbuilding Company's Toledo, Ohio, drydock. Like the *Ann Arbor No. 1* and *No. 2*, the *Shenango* twins were fitted with twin screws aft for main propulsion with the forward wheel used as an icebreaking aid. While the concept worked well on ferries in the pack ice found on the rivers and Straits of Mackinac, the bow wheel was ineffective in the slush ice on the bays and open waters of the Great Lakes. *Shenango No. 2* was brought to Lake Michigan and renamed *Muskegon*, and later, *Pere Marquette 16*. (Author's collection.)

In 1895 the Scottish-born, Cleveland, Ohio-based naval architect Robert Logan designed the world's first steel-hulled deep-water railcar ferry for the Flint & Pere Marquette Railroad. The *Pere Marquette*, which entered service in early 1897 between Manitowoc, Wisconsin, and Ludington, Michigan, was built with more powerful twin engines than her predecessors. Originally planned with a bow wheel, this feature was eliminated before construction was completed, based on the advice of the skippers of the *Ann Arbor* and *Shenango* ferries. (Courtesy Wisconsin Maritime Museum at Manitowoc.)

In 1898, *Ann Arbor No. 3* entered service as the Ann Arbor Railroad's first steel car ferry. The ship was designed less elaborately than the *Pere Marquette*, built a year earlier. With small double deckhouses placed forward of amidships and twin stovepipe stacks, *Ann Arbor No. 3* was a sharp contrast to the *Pere Marquette*'s large split cabins and heavy, raked stacks. Robert Logan designed both ships. (Courtesy Wendell Wilke Collection.)

In 1924 the *Pere Marquette* was renamed *Pere Marquette 15*, indicative of the fleet of sister ships that were introduced in the preceding years. *Pere Marquette 16*, the line's only wooden ferry, joined the fleet in 1900, while the *Pere Marquettes* 17, 18, 19, and 20 went into service between 1901 and 1903. This view shows the 15 with rebuilt cabins and taller smokestacks. Also added to the open stern in the 1920s was a hinged, steel enclosure called a "sea gate." Prior to 1911, all cross-lake ferries had open car decks, fully exposed to following seas. The 15 is pictured off the Michigan coastline c. 1930. (Author's collection.)

14

Tied up at her Elberta (Frankfort), Michigan, wharf, *Ann Arbor No. 3* shows off a new single stack and a fresh coat of paint, c. 1910. This was an improvement on her previously undistinguished profile. Much of the early car ferry rebuilds and alterations were carried out by the Milwaukee Drydock Company. When ship lengths exeeded 300 feet, drydocking and extensive repair work was done primarily at Manitowoc Shipbuilding after about 1916. (Courtesy Jean Otto Collection.)

Between 1896 and 1911, Robert Logan designed nine 350-foot car ferries built to the same general hull pattern of the *Pere Marquette*. Two of them had full-length cabins outfitted with staterooms and sleeping berths for large numbers of passengers. Built in 1902, they were the *Manistique Marquette and Northern 1* (later renamed *Milwaukee*) and the *Pere Marquette 18*. These nearly identical sister ships both sank in Lake Michigan, the *18* in 1910 and the *Milwaukee* in 1929. Another of Logan's boats, *Marquette & Bessemer No. 2*, sank in Lake Erie in 1909. The loss of the three ships claimed over 100 lives, and no correlation between the sinkings was found. *Pere Marquette 18* is shown in excursion service at Waukegan, Illinois, c. 1909. (Author's collection.)

In 1903 Craig Ship Building built the *Grand Haven* for the Crosby Transportation Company, running in connection with the Grand Trunk Railway between Grand Haven, Michigan, and Milwaukee, Wisconsin. The ship was the fastest of the early car ferries and was the only cross-lake ferry to possess a distinctive sheer on her car deck. Her profile was unique with widely spaced stacks owing to the placement of her six Scotch boilers. Crosby's traffic never met expectations and they defaulted on their bonds. The ship and route were taken over exclusively by the Grand Trunk in 1905. *Grand Haven* is shown in Milwaukee Drydock Company's stationary drydock c. 1906. (Author's collection.)

The broad width of the *Grand Haven* was one of the typical structural characteristics of the Great Lakes car ferries. By necessity, the bows of the ships were required to be broad as far forward as possible to accommodate four parallel strings of railcars. The ship is shown in the floating drydock at Manitowoc Shipbuilding in the 1920s. (Courtesy Wisconsin Maritime Museum at Manitowoc.)

Ann Arbor No. 5, left, and *Ann Arbor No. 3* are shown mired in ice on Green Bay c. 1912. Designed by Frank Kirby in 1911, the *No. 5* was long considered the early Ann Arbor Railroad fleet's best icebreaker. Her crews affectionately dubbed her the "Bull of the Woods" and the "Old Warhorse." One of the features that set apart the Ann Arbor boats from those of the Pere Marquette and Grand Trunk were their distinctive spoon-shaped cut-away prows, an example of which is clearly seen on the *No. 5* in this view. This enabled the ship to rise on top of and break through fields of sheet ice by her own weight. (Courtesy Theron Haas Collection.)

Manitowoc Shipbuilding Company (MSB) designed a class of six ferries for Lake Michigan's three fleets. Based on the layout of Robert Logan's ships, the new class evolved subtly in profile and was slightly larger and more powerful. The lead ship was the *Pere Marquette 21*, shown here heading to her sea trials off Manitowoc. She and twin sister *Pere Marquette 22* were constructed in 1924, followed by *Ann Arbor No. 7* in 1925; and Grand Trunk's *Grand Rapids* in 1926, *Madison* in 1927, and the *City of Milwaukee* in 1931. MSB customized each ship slightly as required by the owners. (Courtesy Wisconsin Maritime Museum at Manitowoc.)

By the late 1920s and early 1930s, Pere Marquette Railway officials recognized the potential of the rising popularity of automobile touring, and began marketing its ferries to capture this traffic. Consequently, *Pere Marquette 21* and *22* were rebuilt in 1936 with additional staterooms and lounge space, while more car deck space was allocated for autos, particularly during the summer months. Wood planking was also placed between the car deck railroad tracks to protect the tires and exhaust systems of the automobiles. The *21* is shown at Kewaunee after her cabin extension during the early 1940s. (Author's collection.)

The Pere Marquette Railway was by far the largest passenger carrier of the three Lake Michigan car ferry lines. In 1929 and 1930, the railroad accepted delivery of the powerful 7,200-horsepower turbo electric-driven *City of Saginaw 31* and *City of Flint 32*. The 381-foot ferries were designed and built by Manitowoc Shipbuilding and were considered the best ferries turned out by the yard up to that time. MSB had a reputation for high-quality workmanship and very staunch construction in all of its ships. Built with substantial passenger facilities, the *31* and *32* reflected the PM's commitment to the burgeoning automobile and tourist trade. The success of the pair set the stage for the final phase in the evolution of Great Lakes car ferry design. *City of Flint 32* is shown at Milwaukee's Maple Street slip c. 1936. (Courtesy Wisconsin Marine Historical Society, Milwaukee Public Library.)

Two

Construction at Manitowoc Shipbuilding
March–September 1940

"Ships . . . they are repositories of hopes of the designers, the builders, the owners, the crew, and of one set of passengers after another."

—Harvey Ardman, *Normandie: Her Life and Times*

By the late 1930s, Pere Marquette's freight and passenger traffic was on the rise, particularly on the Manitowoc and Milwaukee runs. Consequently, Leland H. Kent, the railroad's superintendent of steamships, conducted efficiency studies on a variety of propulsion systems and drew up preliminary plans for a new car ferry. During the summer of 1939 the railroad invited the American Ship Building Company, Great Lakes Engineering Works, Manitowoc Shipbuilding Company, and the Toledo Shipbuilding Company to submit bids on the project. The winning bid of $1,750,000 was awarded in November of 1939 to Manitowoc Shipbuilding. Pictured is an artist's conception of the new ship, which the *Great Lakes News* reported was to "incorporate advanced streamline design in its superstructure." (Author's collection.)

Chief hull draftsman Andrew M. (Andy) Houston, second from right, led Manitowoc Shipbuilding's design team. They collaborated with Pere Marquette's L.H. Kent in drawing on paper the lines of "Hull 311." Kent was well qualified to participate, having graduated from the University of Michigan's naval architecture and marine engineering program in 1925. Shown during the retirement party for Armin Pitz in August 1953 are, from left to right: William L. Wallace, Pitz, Houston, and John Thiell. All served in various executive positions at Manitowoc Shipbuilding. (Courtesy Wisconsin Maritime Museum at Manitowoc.)

Harry Berns, Manitowoc Shipbuilding's staff photographer, most likely captured this first image in the sequence of photos documenting the progress of Hull 311's construction. This view taken on January 17, 1940, shows MSB's mold loft, where measurements of a ship's frames and plates are taken by loftsmen and transferred from blueprints (like those on the table in the foreground) and made into full-size basswood templates (shown laid out on the floor). These are then used by the fabricating department in forming the actual steel hull components, and show the shipyard tradesmen precisely where to punch rivet holes, cut and bend plates, etc. (Courtesy Wisconsin Maritime Museum at Manitowoc.)

Shortly after Hull 311's keel-laying ceremony on March 21, 1940, shipyard workers are shown fastening a section of the keelson (the vertical girder) to the keel plate. Each of the fourteen, 30-foot keel plates, molded to shape, are about one-inch thick. Together they form a rigid backbone, with all major hull components emanating from this point at the very bottom of the ship. As the vessel progresses during construction, additional wooden keel blocks, like those shown, are placed accordingly to support the expanding hull form. (Courtesy Wisconsin Maritime Museum at Manitowoc.)

A riveting gang is shown assembling the web frames that form part of Hull 311's double bottom in March of 1940. These frames were spaced 24 inches apart in much of the hull to give the ship strength and rigidity. The bottom of the ship's structure must bear the weight of all of the rest of the hull, machinery, superstructure, and cargo, as well as withstand the strain of storms and ice. (Courtesy Wisconsin Maritime Museum at Manitowoc.)

Supported by temporary timber shoring, Hull 311's bottom plates take form from the keel plate and keelson, or "vertical keel" assembly. The ship's web framing is being erected in the distance. This view from mid-April of 1940 looks forward from starboard side aft. (Courtesy Steve Elve Collection.)

This view, taken April 15, 1940 looking aft from starboard side forward, shows the beginning stages of the ship's double bottom. This safety feature provided added protection in the event of a hull breach. The plates shown riveted to the top of the transverse web frames form the tank top, which comprises the inner part of the double bottom, which runs the full length of the ship from the collision bulkhead forward to the afterpeak compartment. (Courtesy Wisconsin Maritime Museum at Manitowoc.)

By June 6, 1940, the watertight bulkhead at frame No. 176 (just aft the crew quarters in the "flicker" below the car deck, and No. 5 hold) has been erected. Nine such bulkheads divided the hull into eleven watertight compartments. (Courtesy Steve Elve Collection.)

Looking forward from portside aft, the ship builders have made considerable progress on Hull 311 by the time this photo was taken on July 15, 1940. Clearly visible in the foreground is the curve of the ship's stern, with the bulkhead at frame No. 191 tapering down through the form of the propeller bossings to the base of the rudder. Just forward of the aft bulkhead is the compartment that would house the seagate hoist engine. (Courtesy Wisconsin Maritime Museum at Manitowoc.)

Taken on July 30, 1940, only six weeks before the launching of Hull 311, this view looks forward on the nearly completed car deck. The two large openings at center are where the two 17-foot-tall Skinner Unaflow engines will be placed two decks below. Just forward are the openings for the boilers, and forward of that are what appear to be four (actually eight) narrow openings of the coal bunker hatches. (Author's collection.)

The ship's bow was built with framing spaced very closely on 18-inch centers. Her forward plating was $1^1/_2$ inches thick, roughly double the normal hull plating for a distance of 75 feet aft of the prow. The stem was a steel forging 11 inches wide and 4 inches thick and was meant to be virtually impervious to ice. This view shows all of the structural elements: the forged stem, transverse frames, and riveted shell plating. (Courtesy Wisconsin Maritime Museum at Manitowoc.)

Three
LAUNCH DAY
SEPTEMBER 18, 1940

"Both banks of the river and all available space along the docks of the Manitowoc Ship Building Company were crammed with humanity as the big streamlined ship, decked out in colors and pennants, and resplendent in black, orange and white paint, slipped down the greased ways and into the water of the State street turning basin. It was a thrilling sight."

—Manitowoc Herald-Times, September 18, 1940
"World's Largest Carferry Launched"

Like the *City of Saginaw 31* and *City of Flint 32* that preceded her, Hull 311 adopted a name after a major Michigan city located on the Pere Marquette Railway's mainline. On August 13, 1940, formal announcement was made that "*City of Midland 41*" was chosen as the name of the new ferry. The numeric designation of steamers *31* and *32* reflected their turbo-electric propulsion system, while the "*41*" suffix denoted the new propulsion class of the Skinner Unaflow reciprocating engines. The fleet's earlier lake ferries, designated 15 through 22, denoted the first and second generation of compound and triple expansion engines. With her name and homeport brilliantly painted across her fantail, the *Midland* awaits her launching. (Courtesy Ray Short Collection.)

Manitowoc Shipbuilding's two large gantry cranes loom over the nearly completed hull of the *City of Midland 41* as final preparations are being made prior to her launch day. The *Midland*'s hull form and basic structural elements were quite similar to the *City of Saginaw 31* and *City of Flint 32* turned out by the Manitowoc yard a decade earlier. The ship rests on the stocks of MSB's 680-foot building berth "B," the yard's principal construction berth. (Courtesy Audrey Robertson Boals Collection.)

This image that appeared in the September 16, 1940, edition of the *Manitowoc Herald-Times* provides a perfect starboard, three-quarter broadside overview of the *Midland*'s hull. The hull colors were black with white banding, a white fenderstrake or "rub rail" and a bright orange waterline. The inset shows Helen A. Dow, the ship's christening sponsor. (Courtesy *Herald Times-Reporter* and Manitowoc Public Library.)

The *Midland*'s bow rises gracefully from the stocks at Manitowoc Shipbuilding, as workers begin assembly of the christening platform at lower right. The heavily reinforced bow was designed to withstand the worst of ice conditions encountered on Lake Michigan. (Courtesy Wisconsin Maritime Museum at Manitowoc.)

PERE MARQUETTE RAILWAY COMPANY

AND

MANITOWOC SHIP BUILDING COMPANY

INVITE YOU TO WITNESS

THE LAUNCHING OF THE NEW PERE MARQUETTE CARFERRY

CITY OF MIDLAND

AT MANITOWOC WISCONSIN

WEDNESDAY SEPTEMBER EIGHTEENTH

ONE THIRTY P. M. C. S. T.

North Carolina artist Corydon Bell, noted for illustrating children's books penned by his wife Thelma Harrington, was commissioned by the Pere Marquette Railway to create the drawings for the *Midland*'s launch program. Scheduled for 1:30 p.m., the actual launching took place at 1:58 p.m. to accommodate the large group of guests who arrived late on the *Pere Marquette 22* and for the positioning of the newsreel cameramen. (Courtesy Audrey Robertson Boals Collection.)

CITY OF MIDLAND

LARGEST CARFERRY IN THE WORLD

Length overall 406 feet, beam moulded 57 feet, maximum mean draft 17½ feet, displacement of approximately 8200 short tons.

Driven by twin unaflow steam engines of 3500 shaft horse power each, it will operate at a speed of 18 miles per hour. Steam will be generated by four water tube boilers, fitted with economizers and superheaters, with a guaranteed efficiency of 86½ percent.

The carrying capacity of this boat will be 34 freight cars on the main car deck and 50 automobiles on the top deck.

For the convenience and comfort of passengers, accommodations are being provided through the installation of 74 air-cooled staterooms, including 12 parlor suites, spacious salons both fore and aft, and a beautiful dining room of ample capacity, served by a modernly equipped galley.

It will embody the most modern safety devices, a special feature being division of the hull by steel bulkheads into eleven water-tight compartments, which will permit the flooding of any two compartments without endangering the safety of the boat, and will be the first passenger carrying vessel on the Great Lakes to be so constructed.

The City of Midland, which will be ready for service about January 1, 1941, will be the latest addition to the Pere Marquette Railway Company's present fleet of six steel carferries now operating on Lake Michigan between Ludington, Michigan, and Milwaukee, Manitowoc and Kewaunee, Wisconsin.

The inside of the oversized brown-inked souvenir program describes the *Midland*'s design features. Corydon Bell's illustration depicts a reverse-angle portside launching. The ship actually slid down the ways on her starboard side. Bell's work on the launch program has a classic, richly detailed, if exaggerated "Art Moderne" styling. (Courtesy Audrey Robertson Boals Collection.)

The christening party gathers on the platform beneath the *Midland*'s prow. Sponsor Helen Dow's family was from Midland, Michigan, and represented the industries of that city. Helen's father, Willard Henry Dow, was president of the Dow Chemical Company, one of the Pere Marquette Railway's largest freight shippers. Pictured from left to right are the following: Barbara Gilroy, PM Railway Vice President of Operations Robert J. Bowman, Mrs. Willard Dow, G.D. Brooke, Helen Dow, Dr. Willard H. Dow, and two unnamed young men, presumably members of the Dow family. (Courtesy Wisconsin Maritime Museum at Manitowoc.)

With a bright orange backdrop of riveted hull plating, Manitowoc Shipbuilding Company's secretary John Thiell readies the beribboned ceremonial champagne bottle for Miss Dow. She stands at right with the bouquet of roses and is accompanied by her friend and escort, Barbara Gilroy, center. (Courtesy Wisconsin Maritime Museum at Manitowoc.)

Helen Dow endures a cool overcast day as she poses for publicity photos as an unseen army of 230 men ready the *Midland*'s keel blocking on the launchways beneath the ship's massive hull. The men drive thousands of wooden wedges to raise the ship up a few inches to transfer the ship's weight off the keel blocks and onto the sliding "butter boards," which act like sled runners to carry the hull down the ways and into the water. (Courtesy Wisconsin Maritime Museum at Manitowoc.)

As the moment of launch nears, Barbara Gilroy takes the floral bouquet as Miss Dow grasps the champagne bottle. Pere Marquette Vice President R.J. Bowman awaits the signal as the Dow family watches in the background. Bowman was named PM's President in December of 1942. (Courtesy Wisconsin Maritime Museum at Manitowoc.)

Three Pere Marquette ferries, the steamers *18*, *22*, and *32*, were sent from Ludington to Manitowoc with invited guests and dignitaries who participated in the *Midland*'s launch ceremonies. A special shipboard menu was created for the occasion. Lunch was served on the way over to Manitowoc, dinner on the way back to Ludington. The attractive cover was pink with a blue and red caricature of the *City of Midland 41*. A separate sheet inside was dated September 18, 1940, and was held to the cover by a braided blue cord. (Courtesy John P. Praedel Collection.)

A pre-launch luncheon was held at Manitowoc's Catholic Center, and was hosted by the Manitowoc Shipbuilding Company and Pere Marquette Railway. The wooden rendition of the *City of Midland 41*, shown above, was powered by a motorized crank to simulate rising and falling on the wave crests of Lake Michigan. Seated from left to right are the following PM Railway officials: J.A. Hewitt, assistant general freight agent; J.C. Harms, assistant freight traffic manager; J.P. Kelly, assistant to Vice President William C. Hull; R.P. Paterson, freight traffic manager; Vice President Hull; A.P. Rankin, Vice President of Manitowoc Shipbuilding; W.L. Mercereau, retired marine superintendent; B.N. Maier, general agent; H.E. Hay, passenger agent; C.H. Jens, general agent; and H.F. Walters, general agent. (Author's collection.)

The sun breaks through an otherwise overcast sky as a work gang drives wooden wedges in a series of rallies just prior to launch. The entire wedging process, including rest periods between the wedging rallies, takes about 45 minutes. Manitowoc Shipbuilding's yard superintendent Armin Pitz was in charge of the entire complex, harrowing launch procedure. (Courtesy Wisconsin Maritime Museum at Manitowoc.)

The signal has been given, the pneumatic guillotines have cut through the last few restraining hawsers, and gravity takes over as the *Midland* makes a perfect slide down the launchways. A mixture of tallow and grease is used to lubricate the friction point between the launchways and the sliding timbers. This view overlooks the spectators on the opposite bank of the Manitowoc River. (Courtesy Wisconsin Maritime Museum at Manitowoc.)

This stunning view appeared in *Life* magazine, on the Associated Press wire service, and on calendars distributed by the newspaper carriers of the *Manitowoc Herald-Times*. The 3,400-ton launch weight of the ship kicks up a massive wall of spray on either side of her hull, as newsreel cameramen crank out their footage on a platform made especially for them. Their cameras are visible at the bottom of this photo. (Courtesy Wisconsin Maritime Museum at Manitowoc.)

Shot from the southeast bank of the Manitowoc River, the *Midland* hits the water with a rush in this view from starboard side aft. Always a tense and stressful undertaking for all of those involved, the launch was as flawless as could be. (Courtesy Audrey Robertson Boals Collection.)

34

Manitowoc law enforcement authorities estimated that the size of the crowd on hand to witness the *Midland*'s launching was between 15,000 and 20,000 people. Schools and businesses were closed for the afternoon. For all the painstaking preparation and anticipation, the actual slide down the ways lasted only a few seconds. Just a small fraction of the crowd is seen in this view taken at 1:58 p.m. on September 18, 1940. (Courtesy Audrey Robertson Boals Collection.)

As the *Midland* took to the water and the launch wave subsided, a deep swell surged in the river basin. Manitowoc Shipbuilding's yard tug *Manshipco* is seen rolling deeply in the trough of a swell. A small number of yard workers and spectators standing too close to the riverbank got a thorough soaking, including yard superintendent and launching supervisor A.L. Pitz. (Courtesy Wisconsin Maritime Museum at Manitowoc.)

35

LARGEST CAR FERRY IN WORLD LAUNCHED AT MANITOWOC, WIS.

Photographed by
JACK BARNETT

Described by
LOWELL THOMAS

MOVIETONE NEWS

This title clip from the Fox Movietone News coverage of the *City of Midland 41*'s launching was found in the photo collection of the ship's first skipper, Captain Charles E. Robertson. In the author's attempt to trace the origin of this image, Fox Movietone's archivist, Peter Bregman, Fox Movietone News' Director of Archives, theorizes that Captain Robertson may have obtained the still newsreel segment from a movie theater projectionist in Manitowoc, Milwaukee, or Ludington. Lowell Thomas, longtime voice of Fox's newsreels, narrated the coverage of the *Midland*'s launching. (Copyright Fox Movietone News Inc.)

Four
FIT-OUT
SEPTEMBER 1940–MARCH 1941

"The City of Midland 41, new streamlined carferry of the Pere Marquette fleet now nearing completion, has been moved to a fitting-out berth at the south end of the ship yards. There is steam up in the giant boilers of the big craft . . . the ferry is to leave on its maiden trip early next month."

—Manitowoc Herald-Times, February 21, 1941
"Steam Up on the Midland"

Work on fitting out the *Midland*'s hull began immediately after her launching. The five-month fitting-out period saw the installation of her four watertube boilers and two huge steam engines, which contributed to the ship's overall weight, in addition to her superstructure and interior furnishings. The *Midland* is shown at building berth "D" on the north side of the peninsula upon which the sprawling Manitowoc Shipbuilding was located. The two steam cranes shown are kept busy erecting the cabin deck structure as the ferry's sleek form begins to take shape. (Courtesy Wisconsin Maritime Museum at Manitowoc.)

The connecting rods were single-piece forgings and were bored throughout their entire length to force-feed oil to the crosshead bearings and guides. A Skinner mechanic poses to show the relative size of the component during construction. The photos on pages 38 through 40 can be compared with the engine diagram and guide on pages 124 and 125 in Appendix C. (Courtesy Skinner Engine Company, Author's collection.)

The iron alloy pistons were constructed in two-pieces, which eliminated the need for core plugs. Each forged steel piston rod contained two metallic packings, one for the cylinder and the other for the bulkhead to prevent the cylinder oil and water on the rod from entering the crankcase and mixing with the engine oil. (Courtesy Skinner Engine Company, Author's collection.)

The *Midland*'s Chief Engineer Richard Langrill is shown at the Skinner Engine Company plant during his two-month visit to observe and assist in the construction of his ship's engines. He is pictured standing beside one of the cylinder assemblies, shown lying on its side. (Courtesy Skinner Engine Company, Author's collection.)

A partially assembled cylinder is set in position on the *Midland*'s port engine on the floor of the test bed at the Skinner plant. Each of the engine's five cylinders was bored to a 25-inch diameter. In the foreground lies the base of the starboard engine, with the main bearings shown set in place. (Courtesy Skinner Engine Company, Author's collection.)

Skinner Engine Company employees pose proudly beside the cylinders atop the *Midland*'s starboard engine at the firm's Erie, Pennsylvania, plant. Standing at lower left is the ship's Chief Engineer, Richard Langrill, who assisted in the assembly and testing of the engines at Erie for two months. His experience at the Skinner plant proved invaluable, as the supervising erecting engineer sent by the engine manufacturer died of a stroke two weeks after his arrival at Manitowoc. Langrill and a Pere Marquette machinist took over and oversaw the installation of the two engines at the shipyard. (Courtesy Skinner Engine Company, Author's collection.)

The exposed upper portion of the *Midland*'s port engine is shown with the valve gear's dual camshafts fitted in place (hidden by the horizontal cam box) just below the cylinder heads. Sheet metal shrouding encased the cylinders, including everything shown here. In later years, this casing was removed for ease of maintenance. (Courtesy Skinner Engine Company, Author's collection.)

Chief Engineer Richard Langrill pauses on a railroad flatcar as he inspects the *Midland*'s engine components upon their delivery to the Manitowoc shipyard in early October of 1940. He stands in front of one of the engine bases with its crankshaft assembly. The two engines were shipped by rail from Pennsylvania to Wisconsin on four flatcars. (Courtesy Skinner Engine Company, Author's collection.)

The ship's ten-foot-high seagate lies primer-coated and ready for painting and installation on October 4, 1940. This style of seagate was the heaviest and tallest original design fitted to a Great Lakes car ferry. Earlier ferries were either retrofitted with seagates or had lower ones that were raised several feet to afford greater protection from a following sea. (Courtesy Steve Elve Collection.)

This view looks aft from the *Midland*'s port boat deck as yard workers erect the Texas deckhouse. The heavily windowed section shown here would contain the 12 parlor staterooms. (Author's collection.)

By early November of 1940, the *City of Midland 41* was rapidly taking shape. The ship's pilothouse is roughed out as two workers fit a wooden template for the forecastle hull plating. (Author's collection.)

The *Midland*'s exterior fit-out is nearing completion in this excellent overview looking south toward building berth "D" on the Manitowoc River. The entire superstructure is in place, including stack and after pilothouse. The only remaining external structures to be erected are the masts, seagate, and lifeboats. (Courtesy Wendell Wilke Collection.)

This rear view shows the ship's upper automobile deck just forward of the after pilothouse on the boat deck. Most of the autos were stowed in the open area beside and behind the after pilothouse. A smaller number were parked in the open-ended garage, which can be clearly seen from this angle. Because of wartime material conservation, the dockside automobile loading ramps for access to this upper deck were not yet constructed. It was not until 1955 that ramps were built at Ludington and Manitowoc. (Courtesy Wendell Wilke Collection.)

The *Midland*'s streamlined, tapered stack is nearly finished and ready for the mounting of its Kahlenberg steam whistle and T-4 Triplex air horns. The distinctive tone of the T-4s were first heard on the PM ferries *City of Saginaw 31* and *City of Flint 32*. These were retrofitted and mounted in 1940 on their pilothouse rooftops. The *Midland*'s were mounted on her stack, as they were aboard the car ferries *Spartan* and *Badger*, which came out in 1952–1953. (Courtesy Wisconsin Maritime Museum at Manitowoc.)

A fresh snow has fallen in mid-November 1940 as work is rushed on the completion of Pere Marquette's new flagship. The *Midland*'s progress was hampered somewhat by material shortages and delays in receiving equipment from some of the vendors. The United States was ramping up defense production before declaring war, and slight delays in commercial shipbuilding projects were not uncommon. (Courtesy Wisconsin Maritime Museum at Manitowoc.)

The streamlined profile of the *City of Midland 41* is prominent in this forward end view from November 18, 1940. Streamlining came at a cost to passenger comfort, however slight. The forward deckhouse below the pilothouse created a high-velocity wind stream when the ship was underway. Passengers walking forward to the forecastle were hit with a violent gust of wind, blowing many hats overboard throughout the years. Note the raked windows roughed out in the pilothouse. Sometime during the final construction phase it was decided to install an additional triangular window for improved visibility. See the bottom photo on page 46. (Author's collection.)

This after end view, also taken on November 18, 1940, shows the ship's raked superstructure of the automobile garage and after pilothouse on the boat deck. On the cabin deck cutouts below, the railings have yet to be installed. The doors and widows remain to be finished, as well as the fitting of the seagate. The *Midland*'s fantail retains the graceful curve that was introduced to the Great Lakes car ferries on the *Pere Marquette* in 1897. (Author's collection.)

By January 2, 1941, the finishing touches are made to the *Midland*'s exterior fittings. Two of the ship's three portside lifeboats are in place and work continues running air, steam, and electrical lines to the horn and whistles on the stack. Painting progresses on the black upper band and "red ball" insignia. (Courtesy Steve Elve Collection.)

Work on the davits for lifeboat No. 2 is carried out, as well as the installation of cabin deck railings and the pilothouse windows. Note the triangular, wedge-shaped window (one on each side) that was not on the original drawings. See the outboard profile on page 118 in Appendix B. The light plating above the windows on the upper superstructure was a part of the ship's streamlined aesthetic. This feature replaced the traditional pipe railings like those on the *City of Saginaw 31* and *City of Flint 32*. This photo was taken early January, 1941. (Author's collection.)

The *City of Midland 41*'s four Foster-Wheeler watertube boilers were lit for the first time on Friday, February 7, 1941. Her stack smokes lightly in this photo, taken the following week at building berth "B." Meanwhile, the steam gantry crane is in the process of hoisting aboard the lounge and stateroom furniture. The ship's orange waterline paint is still visible; at least until her coalbunkers are loaded. She awaits her steering pole, "redball" foremast insignia, and wireless aerial. (Courtesy Robert J. Peppard Collection.)

With empty bunkers and her bow riding high out of the water, the *Midland* awaits her dock trials, which were carried out on February 17th and 18th, 1941, while tied up dockside. A Skinner Engine Company engineer conducted the tests under throttled conditions at low speeds of 50 to 60 rpm. Both engines were briefly run slightly over 100 rpm. Faster operating speeds were to be attained during sea trials. (Courtesy Robert J. Peppard Collection.)

This aft view shows the *Midland*'s seagate in place and some last minute detail work being carried out on the car deck and upper deck railings. The large rear-facing windows of the aft observation lounge were one of the ship's unique features. Large leather sectional style lounge sofas curved to form an alcove off the entrance hall. See photos on pages 70 and 71. (Courtesy Robert J. Peppard Collection.)

The *Midland* was to be ready for her trials on Saturday, March 8, 1941, but was delayed 24 hours due to minor adjustments to her Unaflow engines. The ship's exterior was completed by the time her trials and maiden voyage got underway, but her interior was not completed until mid-April, 1941. She is shown here at that time, in her second fitting-out period. Her parlors on the boat deck needed to be finished, among numerous incidental detailing. (Courtesy Wisconsin Marine Historical Society, Milwaukee Public Library.)

Five
SEA TRIALS AND MAIDEN VOYAGE
MARCH 1941

"With schools and stores closed for an old-time marine welcome to the new $2,000,000 vessel, the Pere Marquette dock and adjoining points of vantage along the harbor front were jammed early Wednesday afternoon with spectators awaiting the Midland's arrival. Coming abreast of the breakwater about 2:20 p.m. on her first run from Manitowoc, Wis., were she was built, her arrival was met with wild acclaim. Her trip through the channel was punctuated by a steady series of return greetings . . . tugs, factory whistles, railway locomotives all took up the salute, being joined by the huge crowd, hundreds of whom cheered as the ship steamed to her dock."

—Ludington Daily News, March 13, 1941
"Midland Goes into Active Service"

On Saturday night, March 8th, the *Midland* was moved down river under her own power for the first time to take on a load of coal for her bunkers at Manitowoc's Soo Line Railroad car ferry slip. This impressive scene was captured that night. The ship's officers ordered every possible light to be turned on for the benefit of the Associated Press photographers. This view appeared in newspapers to publicize the sea trials, which were scheduled for early the next morning. (Courtesy Robert J. Peppard Collection.)

This view of the *Midland*'s cylinder casing shows the extreme top of the engine and its close proximity to the bottom of the car deck plating above. The engines stood about 17 feet high and took up all of the available overhead space, due to the inherent need of the vertical clearance on the main deck for the cargo of railroad cars. The cylinder casing was later permanently removed to allow the engineers easy access to the valves and cam mechanism. (Courtesy Wisconsin Maritime Museum at Manitowoc.)

An oiler inspects one of the *Midland*'s Skinner Unaflows just prior to the ship's trials. In the background can seen part of a group of PM Railway executives touring the machinery spaces. The Skinners required a great deal of minor adjustment before and after the trials, and in the hours just before the maiden voyage. (Courtesy Wisconsin Maritime Museum at Manitowoc.)

Shortly after 7:00 a.m. on Sunday, March 9, 1941, Captain Charles E. Robertson brought the *City of Midland 41* down the Manitowoc River from the Soo Line slip and headed out of the harbor for the car ferry's shakedown trials. While most of the city was rising from their beds, dozens of Manitowoc shipbuilders had made their way to the lakefront on their own time to watch their creation head out to sea for the first time. This view was taken from the north breakwall. (Author's collection.)

Viewed from Manitowoc's south breakwall, the *Midland* displays her graceful lines on the way to her trials. The eight-hour battery of equipment and performance testing was held off the Wisconsin coastline between Manitowoc and Kewaunee. The ship was put through her maneuvering tests in a light (unloaded) condition. (Courtesy Robert J. Peppard Collection.)

The *Midland* gets her first taste of the open waters of Lake Michigan as Captain Robertson takes his ship through the gap in the Manitowoc breakwall. During her trials, the twin Skinner Unaflow engines were not pushed to their limits. All of the ship's machinery and maneuvering tests were performed satisfactorily for the steamboat inspectors, American Bureau of Shipping representatives, and her builders and owners. (Courtesy Wisconsin Maritime Museum at Manitowoc.)

Pere Marquette Railway's superintendent of steamships, Leland H. Kent, left, watches from the pilothouse with Captain Charles E. Robertson as the *Midland* puts to sea on the first leg of the ship's trials. The *Midland* was Kent's brainchild, and was a credit to his education in the naval architecture program at the University of Michigan and his apprenticeship as fleet engineer and assistant to the PM fleet's "grandfather," superintendent William L. Mercereau, from 1925 to 1931. (Author's collection.)

The tug *Reiss* escorts the *City of Midland 41* upon the successful completion of her trials. The ship was towed back up upriver to the shipyard for fine-tuning of her machinery, final government inspections and outfitting the passenger quarters on the boat deck. By Wednesday, March 12, the ship would have to be ready, as special dignitaries and the press were issued invitations and passes for the ceremonies planned for that day. (Courtesy Robert J. Peppard Collection.)

This view of the *Midland*'s starboard quarter was captured from the forward mast of the *Ann Arbor No. 3*, the oldest of the Lake Michigan car ferries. The *No. 3* was the first ship to salute the newest of the ferry fleet on maiden voyage day, March 12, 1941, and was coincidentally Captain Robertson's first command. Railroad officials can be seen gathering near the loading apron awaiting the ship's first load of freight. The passenger coach at the lower center of the photo served for many years as the car ferry ticket offices for the Ann Arbor and Pere Marquette Railroads. (Courtesy Robert Peppard Collection.)

A Chicago & Northwestern Railroad steam locomotive pushes aboard the *Midland*'s maiden cargo. The cargo consisted of 32 railcars loaded with 1,526,000 cans of condensed milk. Produced by Manitowoc's White House Milk Co., the consignment was destined for East Coast stores in the A&P Tea Co. chain. An early morning ceremony was conducted off Manitowoc after 5:00 a.m. to officially turn the ship over to her owners. PM's superintendent of motive power, R.J. Williams, accepted delivery of the *Midland* from Manitowoc Shipbuilding's Gilbert Rankin and Andy Houston. The ship returned to port and tied up at the lakefront slip. (Courtesy Wisconsin Maritime Museum at Manitowoc.)

A staff member of the Glander commercial photography studio positioned himself on Manitowoc's south breakwater arm to await the *Midland*'s maiden voyage pass on her way out of the harbor. It was shortly after 9:30 a.m., Central Standard Time, March 12, 1941. This slightly retouched photo was used in a variety of magazine advertisements and newspaper features. (Courtesy Marge Miley Collection.)

As the *City of Midland 41* headed out across Lake Michigan on her maiden voyage to Ludington, a photographer for Manitowoc Shipbuilding and the PM Railway boarded a plane for an aerial photo shoot. The weather was perfect; bright and sunny with a northerly wind kicking up a moderate sea. This view was the airplane's first approach from shore, about 15 miles east of the Manitowoc piers. (Author's collection.)

The photographer had the pilot circle the ship at high altitude initially to gauge relative speed. In this scene, the ship is photographed looking southeast into the brilliant glare of the lake's choppy surface. (Author's collection.)

As the airplane circles and descends, Lake Michigan's northerly wave pattern is plainly visible. Consequently, the broadside sea livened up the maiden voyage with a smooth, steady roll. The large rectangular cutouts on the bow provided passengers a view of the mooring winches below. These openings were later greatly reduced in size by deck plating to increase deck space for the summer tourist crowds. (Author's collection.)

(*Above and opposite page*) As the pilot brings the plane down for a low fly-by, the photographer captures the *Midland*'s streamlined profile. The ship's stark black and white livery reflects brightly off the lake's surface. On the opposite page, the plane passes low across the *Midland*'s bow, allowing the photographer to capture what is the most dramatic photo in the series. This classic view shows the ship plowing through the seas at 17-plus mph. Captain Robertson and Chief Engineer Langrill chose not to push their ship to top speed on the first trip. They opened her up to over 18 mph on her second trip, to Milwaukee, later that evening. (Above: Author's Collection; opposite: Courtesy Wisconsin Maritime Museum at Manitowoc.)

This excellent stern view was taken from the observation tower at the coast guard station. The ship's white paint and gray boat deck gleam brightly. Within a few days coal soot would begin marring the new finish. Deckhands were required to scrub the stack daily, but it was a losing battle. The decks were routinely hosed down nightly to prevent fly ash buildup. This view provides a clear view of the garage. The four openings on either side were covered with shutters during the winter months. (Courtesy Arnold Schmidt Collection.)

The brisk northerly winds required Captain Robertson to approach No. 2 slip on "left wheel," as opposed to the normal right turn before backing into the slip. The maneuver requires landing several deckhands down a rope ladder from the starboard bow onto the mooring pilings. The men would then handle the mooring cable. (Author's collection.)

Captain Robertson's friend and colleague, Captain Esten Bahle, had been skipper of the *City of Flint 32* when he suffered a stroke in 1937. Convalescing at his Sutton's Bay, Michigan, home, Bahle was invited by PM marine superintendent L.H. Kent to ride along on the *Midland*'s maiden trip. The ship is shown as she backs toward No. 2 slip for the first time. (Author's collection.)

As the *Midland* was lined up after completing her "left wheel" turn, Captain Robertson turned to Captain Bahle and said, "take her in," and walked out of the after pilothouse, to let his friend complete the final docking procedure. Robertson's touching gesture was no doubt a thrill for Bahle, who briefly came back to his old command, the *City of Flint 32*, although his health prevented him from doing so for long. The ship is shown making her final approach to the apron at Ludington. (Author's collection.)

The Pere Marquette Railway wasted no time in publicizing the March 12, 1941, maiden voyage of their flagship. This full-page advertisement ran in the March 15 edition of *Traffic World*. (Author's collection.)

Six
SHIPBOARD VIEWS
MARCH 1941

"The ultra-modern interior decorations of the S.S. City of Midland will fully conform with the striking, streamline exterior design. Fluorescent lighting . . . leather covered walls and doors . . . gay colors . . . decorative rubber floors . . . and many more new, different features will combine to make this vessel the "Queen of the Lakes."

—Pere Marquette Railway brochure, 1940
The S.S. City of Midland

Among the features that set the *City of Midland 41* apart from her predecessors were her modern onboard amenities. Starting from the forward end working aft, the following series of photos will tour the ship's upper decks. This first scene was taken at the shipyard a few days before the *Midland*'s maiden voyage. The models in this photo series were actually clerical employees of Manitowoc Shipbuilding and the PM Railway. The shuffleboard deck was maintained for only a year or two. In the background is the forward deckhouse, inside of which was the First Mate's stateroom and office. The pilothouse is directly above. (Courtesy Wisconsin Maritime Museum at Manitowoc.)

This is the interior of the First Mate's quarters. The room takes on the streamlined form of the starboard side of the forward deckhouse. The "modern" furnishings were sparse, and the steel walls were a far cry from the more opulent fire hazard of the mahogany paneled walls of the *City of Saginaw 31* and *City of Flint 32*. The earlier ships had even simpler pinewood tongue and groove wall coverings. (Courtesy Wisconsin Maritime Museum at Manitowoc.)

Located above the Texas deck was the ship's pilothouse. From left to right are the port and starboard engine order telegraphs, also known as "Chadburns." Above the third window is the rudder angle indicator. At the center of the photo is the magnetic compass binnacle, wheel stand, and on the tripod behind the wheel is the gyro compass repeater. To the wheel's right is the rudder order telegraph, used during docking. At far right, mounted on the ceiling, is the radio direction finder. The brass handle and switch for activating the Kahlenberg air horns can be seen mounted near the bottom right side of the window at the far left. (Author's collection.)

This is part of the galley, which was located forward on the cabin deck. Much was made of the "modern all-stainless steel galley" and was featured in stainless industry trade publications. Note the "Pere Marquette" floor mat. (Courtesy Wisconsin Maritime Museum at Manitowoc.)

Immediately aft of the galley on the cabin deck was the passenger dining room. The heavy gray wooden tables were bolted to the floor for stability during rough weather. In severe rolling the blue leather-covered chairs were tied tightly together against the tables to prevent damage and injury. (Courtesy Wisconsin Maritime Museum at Manitowoc.)

The steel walls of the dining room were painted light yellow, and the doors leading to the galley were covered with blue leather and were furnished by Morton Manufacturing Company. See the advertisement on page 72. The gentleman in the dark suit, second from left, is PM's office agent, Dan Rathsack, who would later serve as Ludington's mayor. (Courtesy Wisconsin Maritime Museum at Manitowoc.)

This view from 1970 shows how little the passenger dining room had changed over the decades. Above the buffet was a large mural, added in the 1960s, depicting French missionary and explorer Jacques Marquette, namesake of the Pere Marquette Railroad and the original name of the City of Ludington. (Photo by John W. Hausmann.)

Aft of the dining room was the forward passenger lounge. This starboard side night view looking aft captures the full effect of the fluorescent lighting, used extensively in the passenger areas, was a first on the car ferries. The recessed lighting made for a clean, modern look and complemented the leather-covered club furniture. The ship's interior was designed, and its furniture built, by a division of Chicago's Mandel Brothers Department Store. See the advertisement on page 73. (Courtesy Robert Vande Vusse, Pere Marquette Historical Society.)

This daytime view looks aft in the *Midland*'s port side lounge. The staircase led up to the parlor staterooms on the boat deck above, and was a feature unique only to the *Midland*. In the background, the men's smoking room can be seen. The ladies' smoking room was on the starboard side of the center stack casing. (Courtesy Wisconsin Maritime Museum at Manitowoc.)

This view looks forward in the *Midland*'s portside main lounge. The interior design department of Mandel Brothers Department Store in Chicago created an attractive variety of different furniture pieces, all complimentary to each other. A bronze base, the legs of which were securely bolted to the floor, set off each piece of furniture with a brilliant sheen. (Courtesy Wisconsin Maritime Museum at Manitowoc.)

The ladies' smoking room was located on the starboard side of the main lounge amidships, and adjacent to the stack casing. This view looks forward. Beyond the windows can be seen the main lounge. In the 1980s this room was used as a gift shop. The men's smoking room on the other side was converted into a video arcade. (Courtesy Wisconsin Maritime Museum at Manitowoc.)

This view looks forward down the *Midland*'s port side cabin deck hallway. The walls and doors were painted the same shade of light blue as the forward lounge. The 62 standard size staterooms and narrow corridors were reminiscent of Pullman passenger railcar accommodations. The rooms were sparsely outfitted yet comfortable with two bunks (the top was a fold-down), a chair, and a wash basin. Like a passenger car, each room was equipped with a service call push button that actuated a lighted switchboard with corresponding room numbers. (Courtesy Wisconsin Maritime Museum at Manitowoc.)

Purser/Radio Operator Robert Rasmussen is shown sending a message to Ludington shortly after departing Manitowoc on the maiden voyage. He was advising the Michigan PM dock office of the ship's estimated arrival time at the Ludington piers. The *Midland* was delayed by an hour so that shipyard carpenters could finish as much work as possible for the public tours that evening. (Author's collection.)

This view looks toward the starboard side of the *Midland*'s aft observation lounge. This area, also known as the "entrance hall," is where passengers boarded. The seating arrangement provided an alcove for small groups to gather for conversation, card games, etc. In the background the Purser's ticket office window can be seen. (Courtesy Wisconsin Maritime Museum at Manitowoc.)

(*Above and opposite page*) Looking aft in the observation lounge, the large windows overlooked the ship's stern and provided a panorama of Lake Michigan. The cabinets built into the back of the seating were storage space for passenger's life jackets. On the opposite page, two of Manitowoc Shipbuilding's ersatz models light up cigarettes on Mandel Brothers' leather club furniture in this scene looking toward the port side of the observation lounge. Note the patriotic touch of the stars on the floor tile. (Both Courtesy Wisconsin Maritime Museum at Manitowoc.)

The Morton Manufacturing Company played a significant part in defining the "look" of the interior of the *City of Midland 41*. A variety of modern door styles were used, all to good effect. This advertisement shows a few examples of the different styling treatments. (Courtesy Jeffery W. Covert, Morton Manufacturing.)

As Luxuriously Livable as an Ocean Liner!
The "City of Midland" New $2,000,000 Carferry

Interiors and Furnishings Planned and Executed
by Mandel Brothers' Contract Department

You step out of humdrum reality into an enchanting new world when you go aboard the passenger deck of Pere Marquette's new "City of Midland". Never before has a vessel of this class featured interior decorative effects and appointments of such luxury.

Gay colors and floor designs. White satin finish furniture of stainless steel framework and blue-green leather coverings. Luxurious lounges, writing and smoking rooms.

Airy staterooms beautiful with light-colored furniture and fixtures. All "plus" features usually offered for your comfort only on ocean-going liners.

MANDEL BROTHERS' complete interior decorating service—from DESIGN to COMPLETION—relieves ship owners and naval architects of a heavy burden. Responsibility is undivided — which is your assurance that every detail is carried out.

MANDEL BROTHERS CHICAGO

The interior design department of Mandel Brothers Department Store in Chicago did a tremendous job in assuring that the *Midland* was unlike anything that sailed the Great Lakes. Particularly unique was the ship's main lounge staircase and aft observation lounge. (Author's collection.)

Skinner Engine Company's Unaflow steam engines were widely considered to be the "Cadillac" of steam reciprocating propulsion and enjoyed a worldwide reputation of ruggedness and dependability. The *Midland*'s two five-cylinder Unaflows were popular with her engine department personnel. The ad shows one of the ship's engines completely built up with the cylinder head casing in place, and an engineer standing beside for perspective. (Courtesy Sam Steiner, Skinner Engine Company.)

Seven
THE PERE MARQUETTE ERA
1941–1947

"Viewed from the riverbank opposite her moorings, her rakish stack, displaying the huge red-ball insignia of the Pere Marquette fleet, and the superstructure atop the huge but graceful hull, seem to dominate the Manitowoc skyline. Her flowing white band encircling her black hull accentuates her streamlined design and gives her more the appearance of a fast modern liner of the Trans-Atlantic lanes than that of a Great Lakes carrier."

—J.F. Doherty, Cleveland, Ohio

Immediately after the *City of Midland 41*'s maiden voyage afternoon open house at Ludington, the ship joined the rest of the Pere Marquette fleet in making freight runs to all of the lines' ports of call. In the spring and fall, the ship was placed primarily on the freight-heavy Milwaukee run. During the summer months, the *Midland* was dedicated exclusively to the automobile and tourist trade on the Manitowoc route. Ludington and Manitowoc were points along cross-country U.S. Highway 10, with the ferry route connecting the two ports heavily promoted by the American Automobile Association. The ship is shown at Ludington unloading her maiden voyage cargo. (Courtesy Jim Fay Collection.)

Against the backdrop of Milwaukee's Jones Island sewage treatment plant, the *City of Midland 41*'s white paint scheme still shines a few weeks after entering service. The lower portion of the lifeboats and davits were painted black to match the ship's top band on the hull. See a shipboard view of this on page 77, top photo. Milwaukee's wartime industrial output was significant, and much of this freight was carried out of the port by PM's car ferries, as well as the Grand Trunk Western Railway's boats. (Courtesy Wisconsin Marine Historical Society, Milwaukee Public Library.)

The *Midland* is shown heading out of Ludington harbor in the spring of 1941. She was originally certified to carry 376 passengers, but with the addition of lifesaving equipment, the number of passengers allowed was gradually increased over the years. At the end of her career in 1988, the capacity was 609. (Author's collection.)

The large red ball "fast freight" insignia dominates the *Midland*'s tapered white stack. The colorful design was eye-catching, but was nearly impossible to keep clean. More importantly, with the onset of World War II, the PM Railway was criticized in some circles for the design, which resembled the Japanese "rising sun" symbol. In the transportation industry, the "red ball" signified speed; PM began using the form on its ship's stacks as early as 1927. Visible at the top of the stack is the main steam whistle and a set of model T-4 triplex airhorns, both built by Kahlenberg Brothers of Two Rivers, Wisconsin. (Author's collection.)

The *Midland*'s white upperworks were notoriously difficult to keep free of coal soot and fly ash. In this view from early 1941, the situation is at its most extreme, and was not typical. Occasionally an inferior grade of bunker fuel was the cause of this spectacle of coal-fired steam propulsion. (Courtesy Historical Collections of the Great Lakes, Bowling Green State University.)

The *City of Midland 41* was constructed through the U.S. Maritime Commission's ambitious and successful defense shipbuilding program that began in the late 1930s. In the fall of 1941, the U.S. Navy had seriously considered converting the ferry to a small aircraft carrier for training pilots, but instead selected the sidewheel Lake Erie passenger ship *Seeandbee*. The *Midland* was already playing a part in the war effort by hauling freight cars in the industrial Midwest, the heart of America's war production. Starting in November of 1942, PM's Lake Michigan fleet was used to train U.S. Coast Guard recruits in the basics of seamanship. (Three of them are shown here acting as wheelsman, lookout, and radio direction finder operator in the *Midland*'s pilothouse). L.H. Kent oversaw the program as a Commander in the temporary Coast Guard Reserve. The Captains and Chief Engineers were appointed Lt. Commanders with First Mates and First Assistant Engineers appointed as Lieutenants. (Courtesy Audrey Robertson Boals Collection.)

In addition to the coast guard enlisted men (some of which are shown here spelling out U-S-C-G with signal flags), U.S. Navy engineering crews were also trained aboard the *Midland*, beginning in December, 1942. The ship's Skinner Unaflows were nearly identical to those aboard 50 Casablanca-class CVE "baby-flattop" escort aircraft carriers. Royal British Navy engine personnel joined their U.S. counterparts in March of 1943 for intensive one-week training courses on handling the *Midland*'s engines in quick reversing, high-maneuvering situations during docking procedures. (Courtesy Audrey Robertson Boals Collection.)

Captain Charles E. Robertson is shown standing behind the *Midland*'s pilothouse. Mrs. Blanche J. Fritz "wears" a lifering during a trip on August 27, 1943. Robertson was noted for entertaining passengers and guests of the company. As fleet captain of the line's flagship, he was well known by regional newspaper staff writers. He is shown in his Coast Guard Lt. Commander dress uniform. (Courtesy Audrey Robertson Boals Collection.)

Robertson poses on the *Midland*'s bow shortly after his ship entered service. He brought out the *Pere Marquette 21* and the *City of Saginaw 31* new from the shipyard, as well as the *Midland*. His son Bernard carried on the family tradition and also became a captain and brought the C&O car ferry *Badger* out of the Christy Corporation yard in 1953. Charles Robertson was PM fleet captain when he died in 1944. (Courtesy Audrey Robertson Boals Collection.)

Within a few months of entering service, the *Midland*'s four pilothouse windows that opened were retrofitted with sheet metal visors, visible in this scene from 1942. They altered the appearance and symmetry of the pilothouse, but protected the navigation crew from rain and spray. The captain's position between the engine telegraphs threw off the balance of the widow spacing, favoring the port side. This imbalance is obvious in the deck view on page 99, bottom, and was one of the ship's quirky features. (Courtesy Jim Fay Collection.)

In July 1947 the Chesapeake & Ohio Railway absorbed the Pere Marquette Railway. The car ferry fleet retained the red ball stack livery, seen here on the *Midland*'s black painted stack, until the spring of 1950. At that time the C&O adopted their distinctive "double donut" of interlocking letters "C" and "O" on the ship's stacks. News reports stated that the lettering was black lettering on a yellow ball. (Author's collection.)

Eight
THE CHESAPEAKE & OHIO ERA
1947–1983

*". . . Never weary pointing your bow, Toward the biggest waves, get through somehow.
Kewaunee, Milwaukee, Manitowoc a dream, Til the lights on the shore distant are seen.
And during the day when the light is so clear, You capture the mind with memories dear . . ."*

—Tom Cubberly, from *Ode to the City of Midland Str. 41*

Not long after the PM ferry fleet became part of the Pere Marquette Division of the Chesapeake & Ohio Railway, plans were made to add two new ships to the roster. The *Spartan* and *Badger* entered service in 1952–1953, followed in 1954 with the lengthening and repowering of the *Pere Marquette 21* and *22*. During this time, the *City of Midland 41*'s livery was updated. The ship is pictured above, c. 1954, with her broad white hull stripe along the cabin deck narrowed drastically. The "rubrail" bumper was painted black years earlier, and a racy black top band was added to the Texas deckhouse superstructure. Her stack, as well as those of her running mates, was painted a deep "enchantment blue," with an insignia of similar blue lettering on a bright yellow disk. (Courtesy John W. Hausmann Collection.)

This view looking aft on the *Midland*'s portside car deck shows the efficient method of fueling the coal-powered Great Lakes car ferries. While most bulk carriers were required to fuel their bunkers at coaling stations stationed throughout the lakes region, the ferries simply had their bunker hatches, located between the car deck railroad tracks, and had hopper cars dump the coal directly into the bunker below the car deck. Two deck hands are shown opening a car's hopper gates, under the supervision of mate Ingvald Iverson, c. 1950. The car shown was one of 25 ex-PM hoppers, similar to standard ore cars, used specifically for fueling the Ludington-based car ferries. (Author's collection.)

The Chesapeake & Ohio Lake Michigan fleet encountered some of the most arduous winter ice conditions in early 1963. Six of the seven ferries were running that winter, and were delayed on numerous occasions off both the Michigan and Wisconsin shores. With the prevailing westerly winds, the Ludington coast bore the brunt of the heaviest ice fields. With nearly all of the fleet in service, the ships were able to assist one another in breaking through heavy ridges of ice, and were often dispatched across the lake in pairs. This view from February 1963, taken aboard the *Spartan*, shows the *City of Midland 41* breaking a path through a windrow, with the *City of Flint 32* in the background. (Photo by Mary DuBrow.)

82

Car ferry historian John Hausmann captured the *Midland* in Ludington's No. 2 slip in July, 1965. This rare view shows the ship's name on the bow reading "*City of Midland*." This was the first time that the ship's name was painted in large black letters on the broad white band. During her first decade in service her name was painted black on small, ten-inch-high brass letters. Later, when the band was narrowed, the small letters were painted white on a black background. See the photo on page 81. Why the "*41*" was dropped from her official name is uncertain, but it appears that this was the only such occurrence. The following year the lettering was stretched out a bit and had the number added. (Photo by John W. Hausmann.)

On November 27, 1966, Captain Henry Gates intentionally allowed the *Midland* to drift aground just inside Ludington's breakwall during a heavy gale. Returning from Manitowoc with 128 passengers, 56 crewmembers, 47 autos, and a load of railcars, the ship was unable to safely enter the narrow channel in the face of 70 mph winds and high seas. The captain, not wanting to endanger lives or damage his ship on the pierheads, put his ship into the sandy bottom. The incident, reported on network television newscasts, was resolved by November 30th, when the tug *John Purves*, assisted by the *Midland*'s 6,000-horsepower engines, pulled the ship free, with little damage and no injuries. (Courtesy Ron Graczyk Collection.)

The *Midland* loads in the C&O Railway's west slip at Manitowoc's lakefront. The Ann Arbor Railroad fleet used the east slip, at left. The Chicago & Northwestern Railroad serviced this facility, while the Soo Line handled the slip upriver. This scene was taken in May of 1970 from the bow of *Pere Marquette 21* on her way outbound from the Soo Line slip. (Photo by John W. Hausmann.)

The *City of Midland 41* swings around to back into the Jones Island slip at Milwaukee in November, 1970. By this time, the C&O and Ann Arbor Railroads were looking to abandon some of their ferry routes as they were viewed unprofitable. A number of factors, including diminishing freight traffic, improvements in traffic routing around the bottom of Lake Michigan, and rising labor costs, among others, conspired to bring about the decline of the railroad car ferry era. For detailed information on the abandonment legalities, consult the listed works on page 128. (Photo by John W. Hausmann.)

The C&O Railway in the early 1960s sent a General Motors Electro-Motive Division SW-9 switch engine, No. 5251, to service its ferries at Jones Island, after closing the Maple Street slip. The C&O contracted the train crews from the Milwaukee Road, rather than relocate crews from Michigan. Here, brakeman Jim Hawkey releases an idler car for unseen engineer Ed Bunce during the mid-1970s. (Author's collection.)

On a late December 1976 afternoon, the *City of Midland 41* heads out of Kewaunee bound for Ludington, as the *Badger* prepares to pass inbound in the distance. By this time the C&O was in a full-scale effort to abandon its ferry service. The railroad was embroiled in court proceedings with the Interstate Commerce Commission beginning in March 1975, until a September 1978 ruling was issued, allowing the C&O to systematically abandon its three routes. Despite appeals against the decision, the plan moved forward during the late 1970s. (Photo by Andrew LaBorde.)

Winter lake conditions in February of 1977 were worse than those of 1963, and were made tougher by the fact that only two of the now greatly reduced three-ship fleet were in service at a given time. Westerly winds created high-stress pressure ridges in the ice off Ludington, but Lake Michigan's surface was covered with ice of varying thickness from shore to shore, with few open spots, during much of the winter. This aerial view shows the *Midland* attempting to loosen her grip in the ice by using quick-water from her twin screws. Note how rapidly the ice froze in around the ship. Conditions deteriorated to the point that the railroad's officials in Cleveland left the decision to continue service up to Captains Barth, Bissell, Skibin, and Stowe. The skippers realized that if they tied up that February, the chances of ever seeing their ships return to service would be slim, given the abandonment efforts. The men pressed on through the winter, however costly in time and fuel consumption. (Courtesy Captain Ernest G. Barth Collection.)

Seaman Dave Lilleberg, aboard the *Spartan*, got this impressive view of the *Midland* working through a field of slush ice off Ludington in February, 1977. Later that month, one of Captain Barth's relief captains took the *Midland* into windrowed ice outside of Ludington harbor and became stuck. While attempting to break free the port screw lost all four blades, one of which punctured a two-foot gash in the hull below the waterline, flooding a small compartment. One of the tips of the starboard screw was also broken, and a rudder support pin was lost. The ship, replaced by the *Badger*, was tied up the remainder of the winter, and was repaired in the spring. (Photo by Dave Lilleberg.)

In the 1970s, the C&O Railway began referring to its ships as the Chessie System car ferries, as a result of the railroad's consolidation with other eastern railroad companies. In late 1974, the familiar "C and O for Progress" herald, shown here on the *Midland*'s entrance hall direction board, was replaced on the fleet's stacks with the words "Chessie System." During the spring of 1976, the ship's stacks were repainted with a large colorful herald featuring a large dark blue letter "C" inside of which was a silhouette of the sleeping "Chessie" cat, on a bright yellow disk. A red band encircled the larger yellow disk. This change in stack colors remained until several months into the change of ship's ownership in the summer of 1983. (Photo by Andrew LaBorde.)

The *Midland* is shown at Ludington's No. 2 slip. This approach was made using the left rudder. The bow was brought up to the end of the slip where the car handlers would be put off for handling lines. The approach was particularly effective in strong northerly winds and added a few extra minutes to docking time. It was referred to as a "Manistee Turn" because the effect was to turn the ship's head towards the town of Manistee, 30 miles north of Ludington. (Author's collection.)

Max Hanley took this photo of a freshly painted *City of Midland 41* outbound at Ludington from the base of the north breakwall lighthouse in the late 1970s. This and the photo below show off the ship's unusually clean stack and bright "Chessie in the letter-C" herald. (Photo by Max Hanley.)

The *Midland* awaits her turn to use Ludington's No. 2 slip, which is occupied by the *Badger*. Doug Goodhue took this view from the *Badger*'s bow in June of 1981, two years before the transition in ownership was made from the Chessie System to the Michigan-Wisconsin Transportation Company. (Photo by Douglas S. Goodhue.)

Nine
The Michigan-Wisconsin Transportation Era
1983–1988, The *Midland*'s Final Years

*". . . Now trains no longer rumble your deck, Gliding over steel so firmly set.
Echoes of Laughter, shouts and tears, Fill the air where you appeared.
No, the shoreline visage is not the same, Time caught you in its sad refrain.
Able seamen say one by one, I will miss you, my friend, Old 41."*

—Tom Cubberly, from *Ode to the City of Midland Str. 41*

Ludington businessmen Glen Bowden and George Towns formed Michigan-Wisconsin Transportation Company (M-WT) in July of 1983, just as the Chessie System was slated to abandon its last remaining ferry run to Kewaunee. M-WT quickly reinstated the Milwaukee route, abandoned in October of 1980, using the *Badger*—though for summer passenger and automobile traffic only. After two seasons of mediocre results, the route was again abandoned. In the meantime, the *City of Midland 41* maintained year-round freight car, auto, and passenger service between Ludington and Kewaunee. The *Midland* is shown heading out of Kewaunee in the fall of 1986 with a lowered seagate. The seven large windows on the cabin deck mark the location of the aft observation lounge. (Photo by Douglas S. Goodhue.)

M-WT did not immediately change the circular stack heralds on the *City of Midland 41* and *Badger*. By fall 1983, the Chessie colors were painted over in bright red paint, harkening back to the Pere Marquette "red ball" herald. In late fall, the ships received interconnected white "M-WT" lettering on the red background. See page 93, bottom photo. Doug Goodhue took this impressive view from the hill south of Kewaunee harbor in September 1983. Standing on the pier to the right of the lighthouse are Ken Ottmann and author Art Chavez. (Photo by Douglas S. Goodhue.)

The author snapped this photo from the Kewaunee channel pier at nearly the same instant as Doug Goodhue did from the hillside in the photo above. The weather was blustery with an east-southeasterly sea, and was one of the last days the Chessie System Railroad herald would grace the stack of the Lake Michigan car ferries. (Photo by Art Chavez.)

This photo shows the cabin deck from forward on the *City of Midland 41*'s starboard promenade. The generously wide, open deck space provided shade from the sun and protection in the rain and provided passengers with room to stroll and to relax on deck chairs during the busy summer season. This additional space relieved the congestion in the forward and after lounges on full-capacity trips during the months of peak passenger patronage of July and August. Structurally, from this vantage point—particularly the cabin superstructure, framing, and deck plating—the *Midland* closely resembles her immediate predecessors, the *City of Saginaw 31* and *City of Flint 32*. (Photo by Douglas. S. Goodhue.)

The staircase leading from the main lounge forward on the cabin deck up to the parlor staterooms on the boat deck was a feature unique to the *City of Midland 41*. At the top of the stairs was a landing that led to port and starboard, and up to a windowed vestibule. Beyond a double set of doors were the 12 deluxe parlors. In later years, three of the starboard parlors were converted into accommodations for the crew. These rooms included a toilet and shower. (Photo by John W. Hausmann.)

Captain John F. Bissell is shown backing the *Midland* up to the apron at Ludington. During the docking procedure, the rudder is put hardover and the ship's direction is controlled by using the engines, either one at a time or in concert with one another. Speed is controlled by fore and aft directional thrust of the twin screws, depending on the circumstance. Every docking is different due to the changing weather conditions. Often, an anchor is dropped to aid in keeping the bow in place during windy conditions. Bissell retired from his career on the car ferries on September 28, 1985, while serving as captain of the *Midland*. Starting as deckhand, Bissell rose to command Chessie's three ferries, the *Spartan*, *Badger*, and *City of Midland 41*, as well as Grand Trunk Western's *City of Milwaukee*. (Photo by Douglas S. Goodhue.)

The furnishings of the *Midland*'s 62 staterooms on the cabin deck were simple, yet comfortable. Two bunks, a sink, and a seat provided overnight travelers (particularly on the six-hour night run from Milwaukee) a full-night sleep. The staterooms lacked a private toilet, a luxury that wouldn't be forgotten when the *Spartan* and *Badger* where built in the 1950s. Passengers were required to use the *Midland*'s public restrooms, located forward of the staterooms, near the main lounge smoking rooms. The steel window shade shown in the photo could be pulled up for privacy at night, to obscure any peering eyes from the promenade outside. The louvers allowed the lake breeze to ventilate the room. (Photo by Douglas S. Goodhue.)

Captain Ernest G. Barth is shown in the *Midland*'s pilothouse in September of 1985, just off the Muskegon, Michigan, harbor. The ship was sent to Muskegon for a goodwill cruise to promote cross-lake ferry service, and was tied up at the Mart Dock for boarding passengers. The famed *Milwaukee Clipper* used this dock for years until the ship was retired from service in 1970. (Photo by Gregg Andersen.)

Throughout the M-WT era, the summer, twice-daily round trip schedule saw the ship depart Ludington at 9:30 a.m. and 9:30 p.m., then returning from Kewaunee at 7:30 p.m. and 7:30 a.m. The schedule was divided perfectly within the 24-hour cycle; four 4-hour crossings with four 2-hour layovers between each trip. This detailed view of the *Midland*'s stack shows the simplicity of the M-WT corporate logo. (Photo by Art Chavez.)

The *City of Midland 41* enters Kewaunee harbor shortly after passing through a rain squall. A fixed light marked a shoal off Kewaunee harbor, which required an approach to the channel from the north. The shoal light was referred to by the car ferry sailors as the "Kewaunee crib." In the early 1970s, the *Spartan* struck the crib in a heavy fog, resulting in minor damage to her stem. (Photo by Douglas S. Goodhue.)

Tom Gilland, left, and Dave Lilleberg clean and paint lifeboat No. 2, on the ship's port side. First Mate Everett Dust was in charge of assigning paint and routine deck maintenance details, and always did a great job keeping the *Midland*'s deck, superstructure, and passenger spaces in order. (Photo by Douglas S. Goodhue.)

Chief Engineer Theron Haas, left, and Captain "Gus" Barth discuss the maintenance schedule of their ship as she lies in the floating dry dock at the Bay Shipbuilding Company in Sturgeon Bay, Wisconsin. The *Midland* was undergoing the replacement of her starboard propeller tailshaft. Manitowoc Shipbuilding Company outgrew their Manitowoc yard when ships longer than 700 feet were routinely being ordered. The owners bought the former Christy Corporation yard in 1970, and changed the name to Bay Shipbuilding Company, reflecting the relocation to Sturgeon Bay. The parent firm still retains the proud and historic lineage in its name, *The Manitowoc Company*. The *Midland*'s 13-foot, 10-inch, 13,650-lb. port propeller is seen in the background. (Photo by Douglas S. Goodhue.)

The disposition of the *Midland*'s original steam whistle is unclear. Some crewmembers claim that the Kahlenberg whistle was blown off its mountings and propelled like a rocket overboard on a foggy day around 1963 or 1964. The original, shown clearly on page 80, bottom photo, was replaced by a deep-toned Leslie-Tyfon model 425-DVEK steam whistle. The new whistle blew in a bass range at a frequency of 87 cycles per second. Technically called a "whistle," the 33-inch long, 21-inch diameter aluminum projector resembled a horn. Here, the *Midland*'s "Tyfon" steam whistle blows for departure at Kewaunee. (Photo by Douglas S. Goodhue.)

Wheelsman Don Miller, seated, checks the *Midland*'s wind gauge as First Mate Everett Dust stands watch on the Kewaunee run. For several years, the *Midland* maintained the Kewaunee route alone, while the *Badger* was laid-up at Ludington after the end of the 1984 summer season, along with the *Spartan*. Ever since her permanent lay-up in 1979, the *Spartan* continues to be used for spare parts to keep her twin, the *Badger*, running. (Photo by Douglas S. Goodhue.)

Milwaukee car ferry photographer Doug Goodhue chartered a small boat to head out into Lake Michigan in advance of the *City of Midland 41* in the summer of 1984. With the heavy swells in the open water, and the car ferry fast approaching, there was little time to get into optimal position for the ship's passing. The ship is shown plowing through the high waves with "a bone in her teeth." (Photo by Douglas S. Goodhue.)

Wheelsman Roger Vitucki keeps the *Midland* on course during a trip in the mid-1980s. In spite of M-WT's effort at building up their freight business, they fought a losing battle. Many of their key customers were already accustomed to the reduction in cross-lake service implemented by the Chessie System in the late 1970s. Consequently, it was difficult to win back the confidence of some of these freight shippers. Competing against the car ferry route were railroads providing fast service around the bottom of Lake Michigan as well as the interstate trucking companies. (Photo by Art Chavez.)

With the future of the M-WT ferry service always in limbo, enthusiasts took advantage of the final opportunity to ride the last of the Lake Michigan car ferries. The crew responded in kind, by sharing their wealth of knowledge, sea stories, and time to show off the inner workings of the operation. An example of that hospitality is evidenced in this scene showing Kristin Ottmann, daughter of Ken and Trish Ottmann of Milwaukee, being permitted to "steer" the *City of Midland 41*. (Photo by Art Chavez.)

Junior Engineer Mike Braybrook visits the *Midland*'s pilothouse during his off-watch hours. Like most of the engineering crew, he was proud to work with one of the last operating sets of Skinner Unaflow steam engines. To this day, there are firemen and oilers who seek out jobs in the firehold of Lake Michigan Carferry Service's *Badger*. Nearly every Great Lakes merchant seaman is aware of the vanishing technology of the reciprocating steam engine, as diesels and steam turbines power most of their ships. (Photo by Art Chavez.)

Standing the 8 to 12 watch (8 a.m. to 12 p.m. and 8 p.m. to 12 a.m.) afforded wheelsman and avid fisherman Mike Van Haitsma time for ice fishing while in port at Kewaunee. He is shown here in January 1988 cleaning perch in his quarters aboard the *Midland*. (Photo by Gregg Andersen.)

The *Midland* is shown arriving at Kewaunee during the fall of 1985. The south channel pier had a raised catwalk leading to the lighthouse at the end of the pier, and was used by the lightkeepers of the four-man station when high waves washed over their path. The lighthouse was automated in 1981, abolishing the keeper's positions, and the catwalk and a radio beacon antenna were removed from the pier around 1986. (Photo by Art Chavez.)

This view from the lookout's position was a prime location to study the *Midland*'s unique pilothouse and open bridgewing structure. One can readily see the asymmetrical placement of the visors that protected the four retractable pilothouse windows. The captain's position at the engine telegraphs was at the visored window on the right, and the wheelsman's position was at dead center, in line with the foremast. The portholes on the quarters housing the Chief Engineer and First Mate, installed in 1969, replaced the original large windows. The modern bar-type radar antenna was installed in 1974, replacing the original 1950 lattice-work radar antenna. (Photo by Art Chavez.)

Captain Barth stands at the "Chadburns" in the after pilothouse as he docks his ship in Ludington's No. 2 slip in 1987. Second Mate Stu Bell stands watch on the right. Visible out the window at Barth's left is the auto ramp at No. 2 slip, and to his right can be seen the *Badger* in lay-up at No. 2$^1/_2$ slip. Behind Bell can be seen the *Spartan*, laid-up at No. 3$^1/_2$ slip. The ship could be navigated from the aft pilothouse, particularly when backing into heavy ice. (Photo by Douglas S. Goodhue.)

This is a composite of two photos looking aft in the *Midland*'s engine room. First Assistant Engineer Robert Fox, at left, is shown at the throttle levers of the starboard 3,000-horsepower Skinner Unaflow engine. On the right, manning the port engine is Chief Engineer Theron Haas. Both men are watching the steam gauges, tachometers, and engine order telegraphs, as the ship makes its approach to the apron. The engines were highly responsive to change of speed and direction. (Photos by Douglas S. Goodhue.)

The Purser's Department was one of four shipboard departments aboard the *City of Midland 41* (the others were the Deck, Engine, and Steward Departments), and the smallest; consisting of solely the Purser, and during the three summer months, an Assistant Purser. Purser Gregg Andersen is shown in his office aboard the *Midland* in this 1986 photo. Long gone are the days when the ship relied on its purser, who also served as radio operator, for communication with other ships or with shore stations. When this photo was taken, the purser's duties included accounting for passenger's cash receipts and preparing required corporate and U.S. Coast Guard paperwork. (Photo by Ken Ottmann.)

The *City of Midland 41* arrives at Kewaunee on a frigid January 1986 afternoon. During the winter months of the M-WT operation, the ship laid up on Sundays and Mondays, giving Ludington channel occasion to freeze up. Tuesdays were therefore the most troublesome with ice. (Photo by Art Chavez.)

Captain Ernest Barth points out a dredging project as he takes his ship out of Ludington harbor. At the *Midland*'s wheel is wheelsman Jake Huggard, and in the background is Chief Engineer Theron Haas. Barth generally stayed in the pilothouse for about 15 minutes after the ship's course was set for Kewaunee. In rough weather, he would stay much longer to alter the ship's heading to assure a smoother ride for the comfort of passengers and crew, and more importantly, the stability of the cargo. (Photo by Art Chavez.)

Dave Frick, right, visits with the *City of Midland 41*'s First Mate, Everett Dust in July, 1985. Frick was an over-the-road truck driver from Mt. Pleasant, Michigan, who used the Kewaunee route as a timesaving alternative to driving around Lake Michigan. Compare the First Mate's office in the 1980s with the top photo on page 64, c. 1941. (Photo by Gregg Andersen.)

Captain John Bissell is shown leaving the *Midland*'s pilothouse, on his way to the after pilothouse to dock the ship at Kewaunee. At this time the mate on watch is in the after pilothouse and has control of the engines until relieved by the captain's arrival aft. This was Bissell's retirement trip on September 28, 1985. His family and friends accompanied him that day on his last crossings as captain. (Photo by Art Chavez.)

Deckhands Jim Doner, left, and Don Short are shown in the *Midland*'s port coal bunker in November of 1986, photographed through the open hatch from the car deck above. The men are removing coal from the framework along the ship's sides, to facilitate inspection from the U.S. Coast Guard and American Bureau of Shipping. (Photo by Gregg Andersen.)

The *Midland* is shown with a load of freight cars on a summer night at Kewaunee in 1985. In order to accommodate passenger traffic during the summer months, freight was only carried on the night crossings. During the winter months, the ship generally made one round trip daily, leaving Ludington at 9:30 a.m. EDT, arriving at Kewaunee at 12:30 p.m. CDT. On the return trip, departure from Kewaunee was at 2:30 p.m. CDT, with arrival at Ludington at 7:30 p.m. EDT. (Photo by Douglas S. Goodhue.)

The *City of Midland 41* is shown entering Kewaunee harbor in the face of a strong southeasterly wind in the fall of 1986. The ship has a very discernible starboard list from the force of the wind. The newer car ferries, like the *Badger*, *Spartan*, and *Midland*, had high sides that acted like a sail when put broadside to high winds. Captain Barth has ordered the ship to pass close to the south pier, to allow for drift in the narrow channel. (Photo by Ken Ottmann.)

In 1969 the *Midland*'s aft mast was removed, due to years of corrosion. Plans were made to permanently relocate the aft range light to the top of the smokestack, and operate her sans-mast, like the *City of Saginaw 31*. Captain Barth, ever conscious of his ship's aesthetics, convinced the marine superintendent's office to order a replacement mast from the Manitowoc shipyard. At about the same time, there was talk of removing the automobile garage, just aft the stack. Once again, Barth intervened. The ship is shown inbound at Ludington in 1985. (Photo by Ken Ottmann.)

The *Midland* is shown backing into the south slip at Kewaunee in the summer of 1986. The powerful wash from her twin screws came into play in removing the *Spartan* off the sandy bottom of Ludington's Pere Marquette Lake in 1985, after being blown away from her lay-up moorings during a gale. The *Midland* backed up within a few feet from the *Spartan*'s hull, and Captain Barth used the prop-wash to act as a dredge in removing sand build-up. On two successive nights, the *Midland* helped two tugs in releasing the *Spartan* from her grounding. (Photo by Douglas S. Goodhue.)

Heavy seas were a routine challenge that faced the crews of the Great Lakes car ferries. The greatest concern was assuring that the railroad cars were properly secured for safe passage across the lake. The most dangerous element was heavy rolling, which over the years on all of the ships, caused cargo to slide off flat cars, or the railcars to tip completely over onto their sides. Viewed from the starboard promenade, or cabin deck, the *Midland* plows through a heavy sea. (Photo by Douglas S. Goodhue.)

After years of trying to "time" a photograph of a wall of spray exploding over a car ferry's bow, the author captured this view over the *Midland*'s starboard bow. Seconds later, the windows were hit as the water shot high over the pilothouse. Unfortunately, the pilothouse windows leaked somewhat, which wasn't much of a problem in this instance, as it was during a heavy rainstorm. (Photo by Art Chavez.)

Doug Goodhue captured this dramatic view of the *Midland* as she made her way up Kewaunee's channel in the teeth of a southeast gale on March 16, 1986. Weather like this was challenging to the wheelsman as he attempted to keep the ship on course, particularly while traversing a narrow harbor channel. If conditions were too severe, no attempt would be made to enter the harbor, and the ship would ride out the storm in the open waters of the lake. (Photo by Douglas S. Goodhue.)

On the same day as the photo above, Ken Ottmann took this impressive series of photos as the *Midland* set out on her return trip to Ludington. The ship is shown pitching heavily just outside Kewaunee harbor. Once she neared the crib light, she began climbing the swells and crashed down into the troughs with startling force. The trip worsened once the ship came out of the lee of Rawley Point off Two Rivers, and into open water. (Photo by Ken Ottmann.)

Ken Ottmann, Doug Goodhue, and the author made a series of helicopter fly-overs to photograph and videotape the *City of Midland 41* off Kewaunee and Green Bay, Wisconsin. The author is shown with pilot Len Jablon on the ground at Kewaunee, on September 8, 1988, while awaiting the *Midland* to arrive two miles off the crib light. The author assisted Jablon and Goodhue in removing two of the helicopter's doors, hiding them in the tall grass and weeds beside the laid-up car ferry *Arthur K. Atkinson*. (Photo by Douglas S. Goodhue.)

At about 11:45 a.m. we could see, from our landing spot, the *Midland*'s smoke as she neared the crib light. We then lifted off to meet her, making multiple passes at different altitudes. Here the ship steams toward the Wisconsin coast with a load of automobiles on her upper auto deck. Due to the high winds, we kept a safe distance from the ship's sides. On a later flight with light winds, we were able to maneuver up close to the *Badger*. (Photo by Art Chavez.)

On four occasions we flew with Len Jablon in three different Hughes 500s. When the *Midland* was sent to Green Bay in October of 1988 for a two-day promotional visit, Ken Ottmann and the author flew with John Wescott in his two-blade rotor Bell Jet Ranger, that was not as smooth and was less maneuverable than the five-blade Hughes 500-D. In this photo, with Jablon at the helicopter controls, the *Midland* has come around the crib light and is steaming at full speed toward Kewaunee harbor in a choppy swell, built up by a strong southerly wind. The *Midland*'s full icebreaking bow and wide beam were architectural features common to the Lake Michigan car ferries, which routinely carried four parallel strings of railcars in year-round service. (Photo by Art Chavez.)

During the *Midland*'s Coast Guard inspection in 1987, inspectors found that the mounts beneath her boilers were in need of replacement, due to severe deterioration. The necessary repairs were waived for a year. Meanwhile, the Michigan-Wisconsin Transportation Company, never financially healthy, faced the prospect of suspending service for at least a month to effect repairs on the *Midland* (and possibly losing shipping contracts) or refurbishing the *Badger*, herself in need of considerable repair. In the end, the company chose the latter course of action, completing the *Badger*'s refit before the *Midland*'s one-year inspection certificate extension expired in November, 1988. (Photo by Art Chavez.)

109

The *City of Midland 41* is seen as she approaches the Wisconsin shore, on September 8, 1988, during the last months of her operational life as a car ferry. M-WT was quoted repair estimates to rebuild the boiler mounts in the $250,000 range. Despite the company's finances, most observers and employees hoped they would find a way to carry out the *Midland*'s repairs, especially in light of the *Midland*'s superior passenger and auto storage layout to that of the *Badger*. (Photo by Art Chavez.)

The *Midland* steers toward the south pierhead of Kewaunee's channel in this 1988 photo. By November of 1988 her inspection certificate expired, and would not be renewed until the boiler mounts were replaced. One of the biggest complaints regarding the *Midland*'s design came from the car handlers and deckhands working the car deck. The clearance between the railcars and stanchions was quite limited in certain areas, particularly in the center tracks, adjacent to the stack casing—requiring, in some cases, for the deckhands to crawl on their hands and knees to put up jacks and chains to securely fasten railcars in heavy weather. (Photo by Art Chavez.)

As Len Jablon flew closer to shore, we were able to descend to a much lower altitude as the ship proceeded up the channel and into her dock. This pass shows the Midland's deck layout, which was ideally suited for the combination of railcars, autos and passengers. When interviewed by the author in 1988, M-WT president Glen Bowden confided that he regretted refurbishing the Badger, and should have spent the money on repairing the Midland. (Photo by Art Chavez.)

We circled the Midland twice in the harbor, and then landed again to retrieve the doors near the Atkinson. By the time we secured the doors and were aloft, the Midland was tied up and the unloading process had begun. We circled once to get an overview of the apron and automobile loading ramp. This ramp had originally been installed at Manitowoc in 1955, and was moved to and rebuilt at Kewaunee in 1983. The ramp and the Midland's upper deck auto storage facilities were a tremendous asset for M-WT. It allowed them to maximize the ship's auto capacity during the peak summer months. The capacity allowed 55 vehicles to be squeezed on top, and about 120 on the main deck, or car deck, below. On the 2:30 a.m. night run from Kewaunee, 24 railcars filled the main deck, while the upper deck could usually handle the lower volume of nighttime auto reservations. (Photo by Art Chavez.)

111

In October of 1988, M-WT President Glen Bowden hosted a two-day, first-ever visit to Green Bay, Wisconsin, by a Ludington car ferry. The *Midland* was used for two shoreline cruises off Green Bay harbor, in an effort to attract the interest of officials and freight shippers of the Burlington Northern Railroad. The dignitaries and their guests enjoyed favorable weather for the weekend cruises, but little benefit came out of the effort. Captain Barth is shown standing beside his ship, tied up near the downtown Green Bay Holiday Inn hotel. The heavy shoal water in the area, unfamiliar to the car ferry's crew, required slower running speeds and careful study of navigational charts. Within three weeks of this visit, the *Midland* was laid-up, never to sail again. (Photo by Douglas S. Goodhue.)

In late 1988 it became apparent that M-WT did not have the resources to repair the *Midland*, let alone survive on a day-to-day basis because of declining freight traffic. At about that time, Captain Barth, the ship's skipper since 1967, began contemplating retirement. On September 29, 1989, Barth brought the *Badger* into Ludington and rang up "FINISHED WITH ENGINES" on the Chadburns, ending his 42-year career on the Ludington car ferries. He was with several friends in the aft pilothouse as he performed this final act. At right is a letter of praise from Michigan Congressman Guy Vander Jagt in recognition of his distinguished career. (Captain Ernest G. Barth Collection.)

On November 16, 1990, M-WT ran out of options and permanently ended railroad ferry service to Kewaunee. Eventually filing for bankruptcy, the operation was purchased by Charles Conrad and his new company, Lake Michigan Trans-lake Shortcut, Inc., operating under the name Lake Michigan Carferry Service (LMC). A route was reinstated to Manitowoc, and the *Badger* was run as a seasonal auto and passenger ferry. After years in lay-up, LMC management decided to convert the *Midland* into a deck barge. She is shown being towed out of Ludington on October 1, 1997, by the tug *Mary Page Hannah*. (Photo by Max Hanley.)

The decision to scrap the *Midland* to her car deck was unpopular with many Ludington-area residents and historians. Lake Michigan Carferry President and CEO Robert Manglitz explained that he was converting the popular ferry into a barge as a means of diversifying and strengthening the firm. Max Hanley caught this last view of the *Midland* being towed south from Ludington toward Muskegon, Michigan. (Photo by Max Hanley.)

Melching, Inc. was hired to strip the *Midland* down to her car deck. The work was carried out at the Mart Dock in Muskegon, home of the *Milwaukee Clipper* from 1941 to 1970. The scrapping process was heartbreaking to many observers, and was extensively documented in photographs. In this view, the smokestack, one of the *Midland*'s most distinctive features, is lowered to the ground by a gantry crane on November 7, 1997. (Photo by Jean Wienand.)

Another of the ship's unique architectural elements, the streamlined forward pilothouse, is lifted clear of the superstructure. Fred Schmitt, one of the *Badger*'s Third Mates, observed, "When the *Midland* remained in lay-up at Ludington, there was always a ray of hope that she would some day be brought back into service." Captain Barth, the *Midland*'s skipper of 21 years, watched as his ship succumbed to the cutter's torch. He was philosophical about the process, commenting that it was a business decision, and lamented that "ships, as well as people, have limited lifespans." (Photo by Roxy Wienand.)

After the *Midland* was cut down to the car deck, the hull was towed to Sturgeon Bay, Wisconsin, for conversion to a notched-stern deck barge. In recognition of the vessel's lineage, the barge was named *Pere Marquette 41*, and mated to a former U.S. Navy tug, the *Undaunted*. The articulated tug/barge combination (ATB) is operated by the LMC subsidiary, the Pere Marquette Shipping Company. (Photo by Max Hanley.)

During her career, which spanned 47 years, the *City of Midland 41* crossed Lake Michigan over 49,000 times and sailed over three and a half million miles, and carried nearly one million railroad freight cars and nearly four million passengers. Her loyal crew will likely recall her glory days, like this one, as she sets out into the sun toward her birthplace in Wisconsin. She will fondly be remembered. (Photo by Tom Cubberly.)

Appendix A

General Specifications

S.S. *CITY OF MIDLAND 41*

CITY OF MIDLAND 41—**U.S. Registry No.** 240326 **Radio Call Sign:** WD 3866
Builder: Manitowoc Shipbuilding Company, Manitowoc, Wisconsin **Hull No.** 311
Keel Laid: March 21, 1940 **Launched:** September 18, 1940
Sea Trials: March 9, 1941 **Delivered (Maiden Voyage):** March 12, 1941
Length: Overall: 406' Between Perpendiculars: 388'
Breadth: Overall: 59' Molded: 57'
Depth: Molded (to main deck): 23' 6" **Draft:** Loaded: 18'
Tonnage: Gross: 3,968 Net: 833 Displacement: 8,200
Railroad Car Capacity (as built): 34 40-foot cars, avg. max. capacity each: 80 tons
Automobile Capacity: Upper Deck Storage Area and Garage: 50 units
On Car Deck, with no railroad cars, approximately 110 units
Car Deck Height: 19' 8"
Passenger Capacity: (as built in 1941): 376 (at end of service in 1988): 609
Staterooms: 62 (standard size, with two bunks, sink, no toilet)—on cabin deck
Parlors: 12 (larger size, with two large bunks, sink, shower, and toilet)—on Texas deck
Fuel: Coal **Bunker Capacity:** 550 Tons **Avg. Daily Fuel Consumption:** 71.2 Tons

Propulsion System

The *Midland*'s propulsion system consisted of two simple five-cylinder Skinner Unaflow reciprocating steam engines built by the Skinner Engine Company of Erie, Pennsylvania. Each cylinder had a 25-inch bore with a piston stroke of 30 inches. The main engines were highly responsive and had a combined normal operating horsepower of 6,000 at 120 rpm and were capable of a combined overload rating of 7,000 horsepower at 125 rpm; extreme overload capacity in excess of this was also available in emergency situations.

Steam was furnished by four D-type two-drum watertube boilers built by the Foster-Wheeler Corporation of Carteret, New Jersey. Each unit had a normal steam capacity of 26,125 pounds per hour, and a maximum output of 39,190 pounds per hour. The design pressure was 390 p.s.i.g. with a pressure at the superheater outlet of 335 p.s.i.g. Final steam temperature was 650 degrees F, and temperature of the feedwater at the economizer inlet was 225 degrees F. Each engine exhausted into an Ingersoll-Rand two-pass surface condenser with 2,400 square feet of tube surface. Each condenser was designed to handle 46,000 pounds of steam per hour, and maintained a vacuum of 26 inches when supplied with 3,200 gallons of cooling water per minute at a temperature of 70 degrees F. For the removal of air, each had a twin element, two-stage, steam-jet ejector, with an inter and after condenser. Cooling water was circulated through each condenser by a single-stage centrifugal pump rated at 3,200 gallons per minute against a head of 25 feet and driven at 700 rpm through reduction gear by a Terry 32-horsepower steam turbine. Condensate was handled by two single-stage pumps, each rated at 110 gallons per minute against 90 feet of head and driven at 1,750 rpm by an Allis-Chalmers $7^1/_2$ horsepower motor.

Propellers

2—Cast Steel, Four Blade. Diameter: 13' 10" Blade Pitch: 14' 0" Weight: 13, 650 lbs. Projected Area: 59.9 Sq. Feet. Starboard Wheel-Right-Hand (Outboard) Turning.

Anchors

2—Stockless. Weight: 5,200 lbs. Each. 2-Anchor Chains $1^{15}/_{16}$" stud link chains, each with three 30-fathom shots, total length each: 90 fathoms.

Maneuvering Characteristics

Distance and Time for a 90-Degree Course Change
Cruising Speed: 110 rpm, .22 miles distance: 90 seconds.
Half-Speed: 70 rpm, .1 mile distance: 55 seconds.

Engine Revolutions Per Minute and Vessel Speed
Weather Conditions at Time of Testing
Wind: North at 10 miles per hour. Draft (forward) 15' 4" Draft (aft) 16' 8"

Engine Revolutions Per Minute	Vessel Speed in Miles Per Hour
40	6
50	8
60	10
70	11.5
80	13
90	14.5
100	16
110	17.2*
120	18.3
130	19.2
140	20

*Normal Cruising Speed

STEAMER
CITY OF MIDLAND 41
MANITOWOC SHIPBUILDING COMPANY
1940

Builders' plate drawing by Douglas S. Goodhue.

Appendix B
Profiles and Deck Plans

MIDSHIP SECTION

Elevation and transverse section through boiler room showing arrangement of boilers, uptakes, conveying machinery and stokers.

Steam is supplied by four D-type marine watertube boilers, each capable of delivering 26,125 pounds of steam per hour.

Appendix C
The Skinner Unaflow Steam Engine

Plans of the Engine Room of the *City of Midland*, showing the arrangement of the propelling machinery and auxillary units.

THE SKINNER MARINE UNAFLOW STEAM ENGINE

1. Throttle valve, balanced for ease of operation.
2. Steam piping designed to permit expansion.
3. Positive piston rod lock.
4. Ample exhaust port area and manifold.
5. Two-piece alloy iron piston. Eliminates troublesome core plugs.
6. Alloy iron cylinder, non-warping. Barrel-bored to compensate for expansion due to temperature gradient.
7. Steam packing (top) and bulkhead packing (bottom), with special bronze rings. Bulkhead packing is liquid cooled.
8. Forged alloy steel piston rod ground to fine finish.
9. Crosshead and pins, single-piece high-carbon steel forging.
10. Crosshead shoe, babbitted top and bottom. This construction allows continuous full-load operation either ahead or astern.
11. Bored crosshead guide. Concentrically rabbeted to cylinder heads and cylinder for permanent alignment.
12. Full force-feed lubrication to all reciprocating parts, through drilled crankshaft, connecting rod, crosshead pins and crosshead shoe.
13. Bearing shell removable by rolling out.
14. Convenient inspection cover.
15. Relief valve protects each cylinder (bottom relief valve not shown).
16. Steam-jacketed alloy iron cylinder head.
17. Maneuvering valve (at each end of cylinder) relieves compression when reversing, and may be held open to permit removal of water from self-draining cylinder and heads during starting. (See "hydraulic valve," number 26.)
18. Pressure lubrication of all cam mechanism.
19. Dual camshafts for accurate timing and positive control of lead and cut-off. All cams, rollers, and gears are hardened and ground to close tolerances. Rollers have line contact on cams.
20. Permanent double ground joint — no gaskets.
21. Steam-tight admission valve (at each end of cylinder). Double-seat telescopic type, with free seat. Permanently tight, regardless of variation in pressure and temperature.
22. Control levers grouped in convenient location. Position can be reversed for operation from upper level. Throttle valve control.
23. Cut-off ahead (or lead astern).
24. Lead ahead (or cut-off astern).
25. Permanent reducing motion, with detent, for each cylinder. Permits taking indicator cards at any time without stopping engine.
26. Hydraulic valve to control opening of maneuvering valves for water drainage from cylinders during warming and starting.
27. Forged steel connecting rod, forked at upper end to reduce height, with heat-treated fitted bolts.
28. Box frame provides rigidity and total enclosure for cleanliness.
29. Rigid base; heavy weldment design in larger sizes; single-piece casting, double-wall construction in smaller sizes.
30. Dry sump to prevent oil loss and oxidation due to splash.

125

LUDINGTON

The "CITY of MIDLAND 41" travels over 4 times around the world every year

MILWAUKEE

POWERED BY... **SKINNER MARINE UNAFLOW STEAM ENGINES**

One of the two 3500-hp. Skinner Marine Unaflow Steam Engines Propelling the "City of Midland 41"

Pere Marquette Railway's "City of Midland 41", passenger, automobile and freight car ferry, operating on a schedule of three trips daily between Milwaukee and Ludington, has run over 500,000 miles since she was commissioned in 1941—with a cost for repair and replacement parts of less than 2¢ per installed horsepower per year!

The "City of Midland 41" maneuvers in and out of the narrow channels at Milwaukee to call at two terminals, and repeats the performance at one terminal in Ludington, as part of her 300 mile daily schedule.

In maintaining a schedule of over 1,000 crossings of Lake Michigan per year, often under severe weather conditions, without a single stoppage due to mechanical trouble, it is said that this vessel travels more miles annually than any other ship afloat. The record of the "City of Midland 41" is strong evidence of the three outstanding characteristics of Skinner Marine Unaflow Steam Engines—their dependability, their maneuverability, their unmatched low maintenance and operating cost.

For Over 75 Years, Doing One Thing Well—Building Steam Engines
SKINNER ENGINE COMPANY, ERIE, PA.
Licensees for Canada: Canadian Vickers, Limited, Montreal